Sakayume
Dreams' Dawn, Enlightened

Daniel D. Henke

Copyright © 2018 Henke Enterprises

All rights reserved.

ISBN:
978-0-578-20577-9

danieldhenke.com

DEDICATION

This book is dedicated to altruism

Sakayume

CONTENTS

My Oceans of Words are The Glow of a Flower & The Path of Music	10-11
They Danced a Rhythm as Each Day Lived Dreams In A Scene & Bouquets of Words We orchestrate	12-21
I Have Some Questions. God Let Me Live. A Sonnet Is A Song. If Love Is A Prize, Desire Is Misunderstood.	22-31
Born Of Water What Do You See? Sometimes We Just Thank The Truth Every Day Emotions Are Spirits, Famously Minded, & Afraid Of The Dark. Don't Doubt The Height in Skies of Blue	32-49
Eclipsing The Colors, Swimming In A Mind, Rolling Tides Sea Deeply. Love Promised Memories Of Passion Too.	50-61
Friends Ask Friends Crazy Thoughts In The Flowers And Storm Of Nature. Close Your Eyes, Castaways, Here Lies The Truth.	62-72
A Boy Could Draw Dimensions Science Can't Define, If You Choose Love. Let's Talk About Living. Men Of Few Words Misunderstood Modern Times' Milky Ways.	73-87
Most Poets Live In Fear. Imaginations Can't Seem Lost Or Found. She Flashed Seven Virtues Secrecy Won't Serve. Play It Hot, Love Is A Language. It's Okay To Have Wonder, Trust, And Love.	88-109
Think Of The Person. Who Is She? The Sunsets Tell Nature's Bastion of The Angels' Valley. The Face Of Your Music, The Music I Write, Our Paths Now One.	110-121
I Wish Music Took A Breath My Teens Were Not. Carriages Hold Moments In Life. Nudity Smiles Sunbursts Flower You Painted Flowers Sun Day	122-135

The rest of the Dreams' Dawn…

OPPOSITE DREAM

If love did come to me as a rose, the sun that's setting, brought the wine. In twilight's time, there's little prose, the colors silencing voices of mine. Love is an ocean and words can be art; the art that's painted, revealing the vines. The art of the tongues is usually unspoken, when twilight's passion starts.

Passion for life is void of rules. Be yourself if you wish to fly. Love is never taught in schools, because knowing love is knowing why. Why are some people just born to ask? Then others tell and can't stop talking. Speaking for love is not a task. We can only learn love while we are walking.

Once again, sunset signals the night; a time to reflect the emotions of day. The colors reflect the dangers of light. Reds show warnings in brilliant ways. Unbending the rules fades the mind towards black. Straight into a place we cannot see. Before you leave color, explore the twilight. You'll want to be certain to find your way back.

The beauty lost by time is the romance of the mind. When over-defined, love can be blind. But then within us, there is forever. Infinity speaks in beams of light. The soul is language, it tongues just right.

Then in our eyes, the soul is trying. Its efforts, focused, guide us to see. The colors we saw, in pictures, lying, are the images, then, that we wished would be. The poet brings the pictures in words. The stoic, reborn, learns value in life. Thrilling words mean more to strife, than fortunate beings that live in right. Acknowledge all, they are there to be. To avoid the fall they need to be free.

CHAPTER NONE

When considering the words you read, keep in mind that they can be applied to many things. Before you read each of the poems that follow, choose what or whom you wish to honor. Then, use the context of the words to reflect on the reality of your conscience.

Your conscience is a bridge between the physical and the non-physical. It generates pieces of your dreams. Concepts create images in your mind. When you consider the concept of Love, you can be referring to Earth, nature, spirit, 5^{th} dimension, or a significant other. How you perceive truth may only be a matter of culture. Think of the sunset as the start of a cycle, rather than an end. Or, try to conceive of no end and no beginning. Consider thinking the opposite of dreams, where the sunset can be viewed as the dawn.

The dawn is a beginning, where light inspires awareness. When applied to sunset, you can't anticipate the content of dreams that follow. The first part of each dream is perceived as light, like a sunrise, but only because your culture defined it as such.

The dreams that come to you are generally not within your control. So dreaming can be thought of as the ultimate method of letting go. Surrendering control, to see what your soul wonders, is a spiritual gift.

The context of words then, mean something more than the context in which your present state of mind resides. Reading, usually extends your current state of mind. The timing of when you read affects how you interpret the words you're reading. Try reading the same poem, during morning hours, and during sunset. Most minds will adopt a different feeling, because all other senses are connecting the now, and the feeling in now. Five senses affecting your interpretations.

The context of images is much different. There are emotions and words that images inspire that we cannot associate, because the emotions and words aren't invented (by our culture) yet. I associate these unknown emotions and feelings with an all-encompassing word, known as wonder.

If you prefer a different word, such as awe, please associate it, instead. The objective is to realize when there are no words to describe a feeling you have, and that it's a good place to be. The images in this book are an attempt to communicate some of the ideas I just described. Each image is associated with a sonnet. I sincerely hope you enjoy them and that they can feed your mind with new ideas.

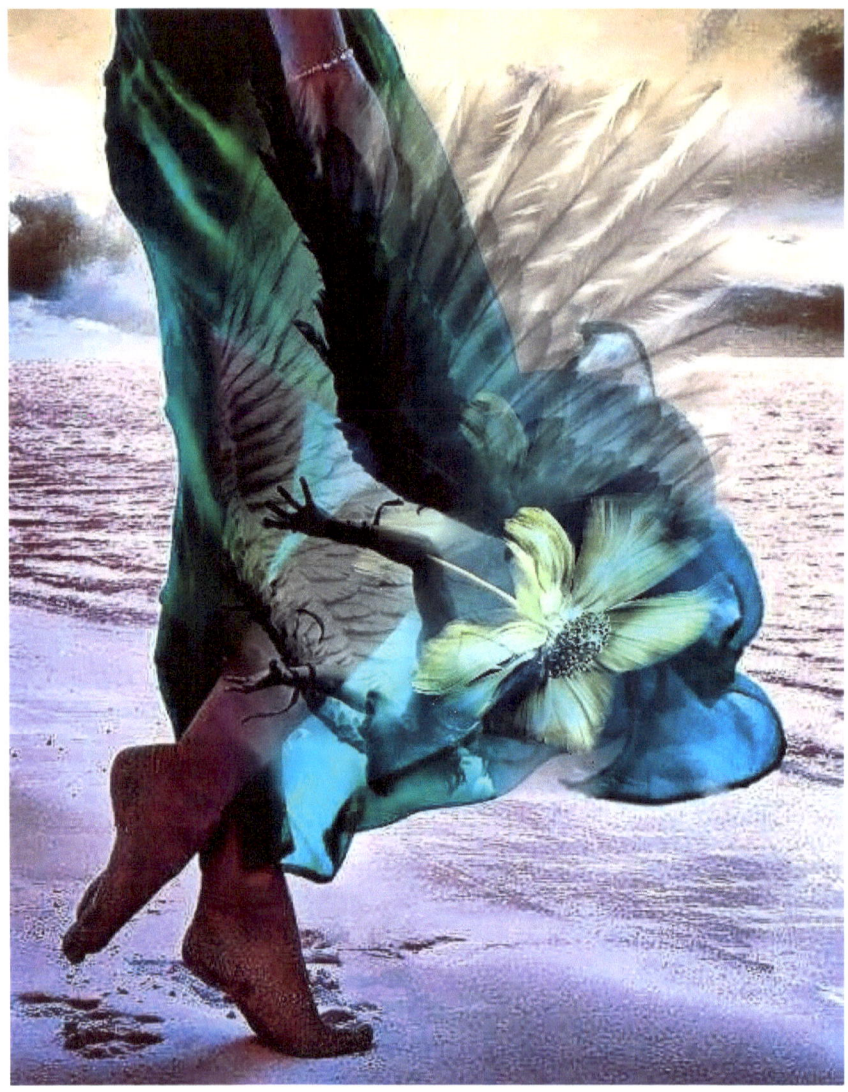

My Oceans of Words

My oceans of words wish for the most peaceful islands of sonnets. The peace is you and I am the sands. We are the nature of our own words, flowing in tides of kindness...

The tide, it turns, a soul, a wake

Karma sways its unseen shifts

Advantage, kindness never takes

Goodness plays with nature's gifts

Gifts are not to be given with force

The best of them just can't be touched

It's energy that takes its course

It's gratefulness that means so much

You are my ocean, my ultimate wish

Your colors gently thank my eyes

My karma white, though devilish

Not materialistic, the jester cried

Living a dream in an ocean of good

Flowers came in our beds, like we hoped they would

DANIEL HENKE

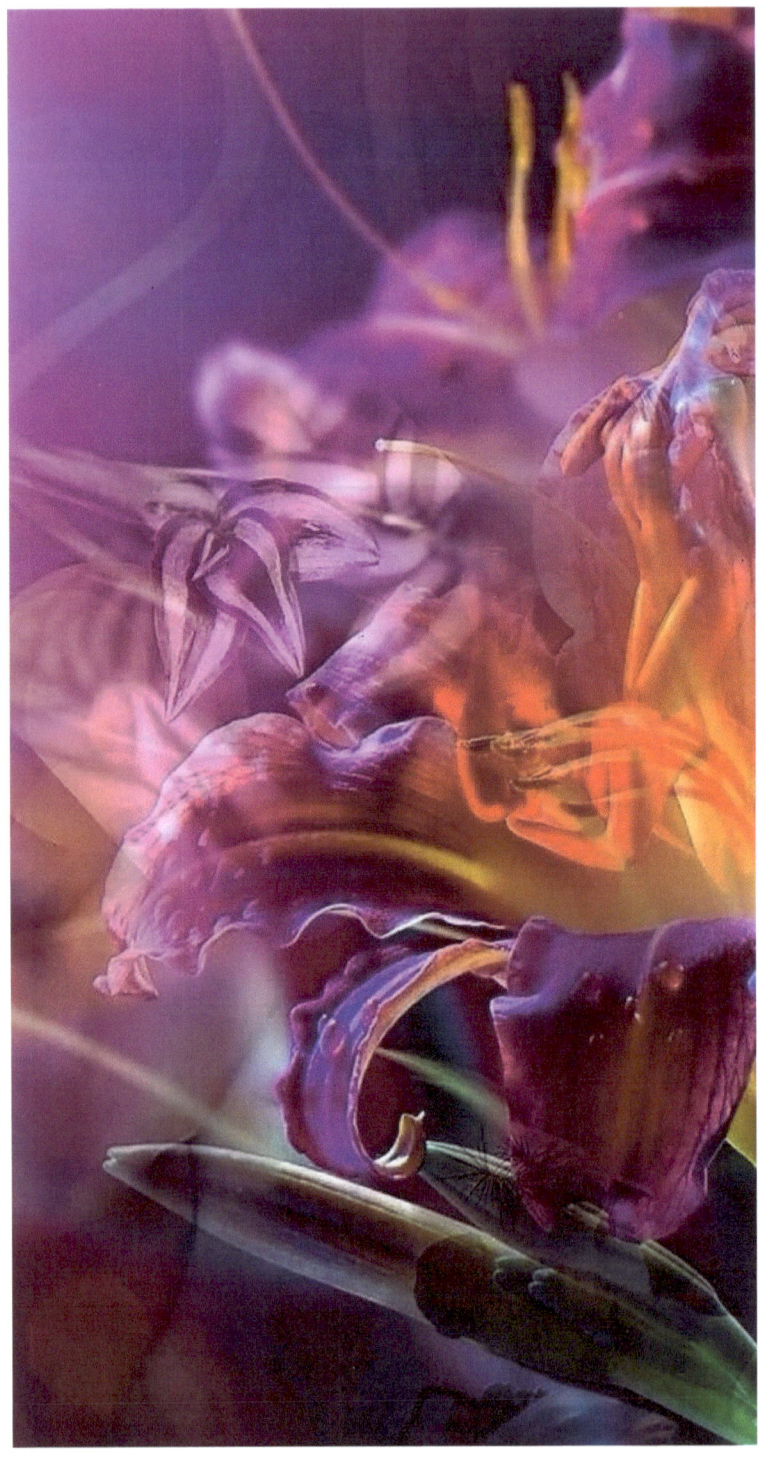

The glow of the flower feels so true

That's why we stare at the colors

The life they share with me and you

Wonders if, they'll attract others

Bound by Earth, we move them around

Hoping to make the perfect bouquet

Why do we take them out of the ground?

That's probably where they wanted to stay

People plant themselves where they bloom

But take for granted the beauty they grew

The flowers follow them to their tomb

But they rarely forget all the things that they knew

The souls of nature regenerate

The colors, that flowers perpetuate

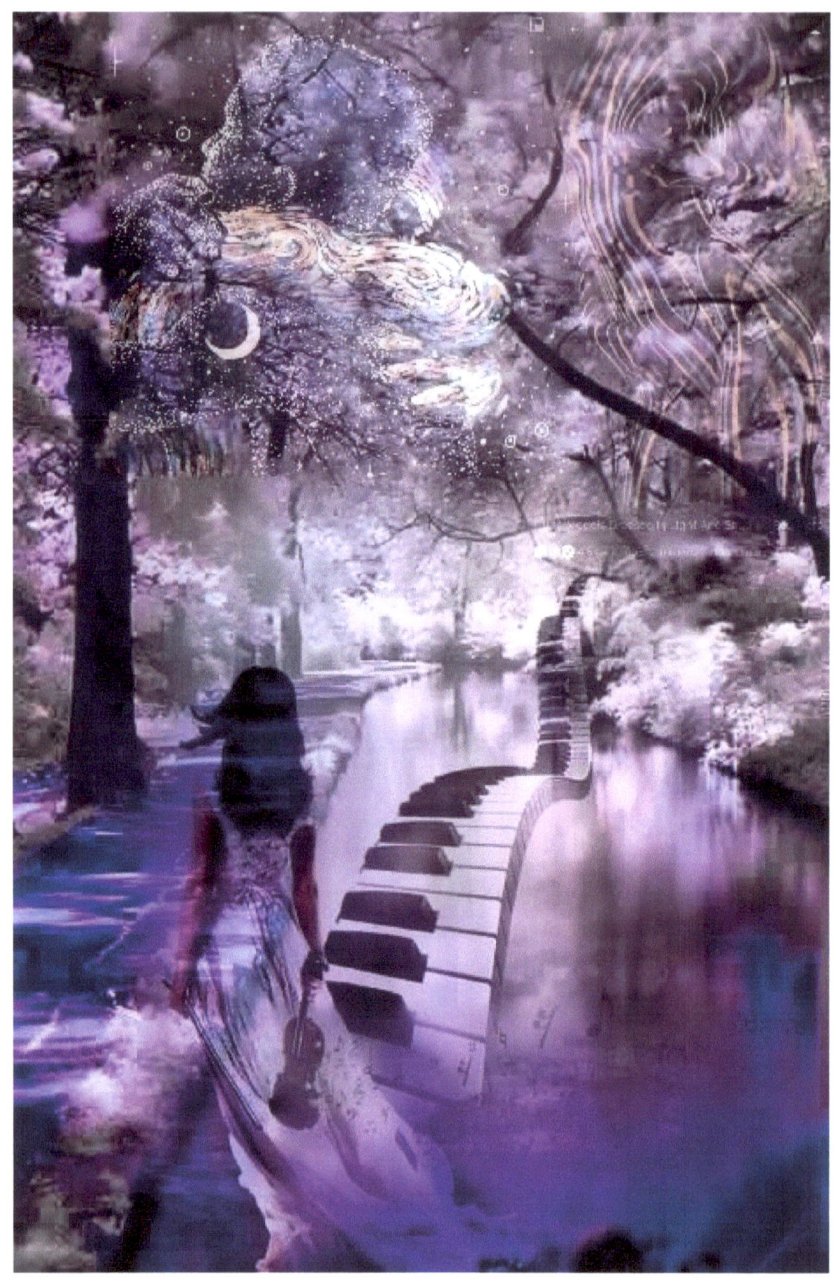

The path of music lovers walk

Purple passion's fork in the road

One way concepts start to talk

The other, the one emotions know

The music you make is all your own

Speaking in tongues shared by just two

Seeing the seeds you haven't sown

Colors of passion enjoying the mood

Walk, but don't run away from here

Enjoy the precious moments you own

Self-guided dreams don't need to steer

The comfort you feel is your only home

Invite them to see much more of your view

The view from the mountain made only of you

DANIEL HENKE

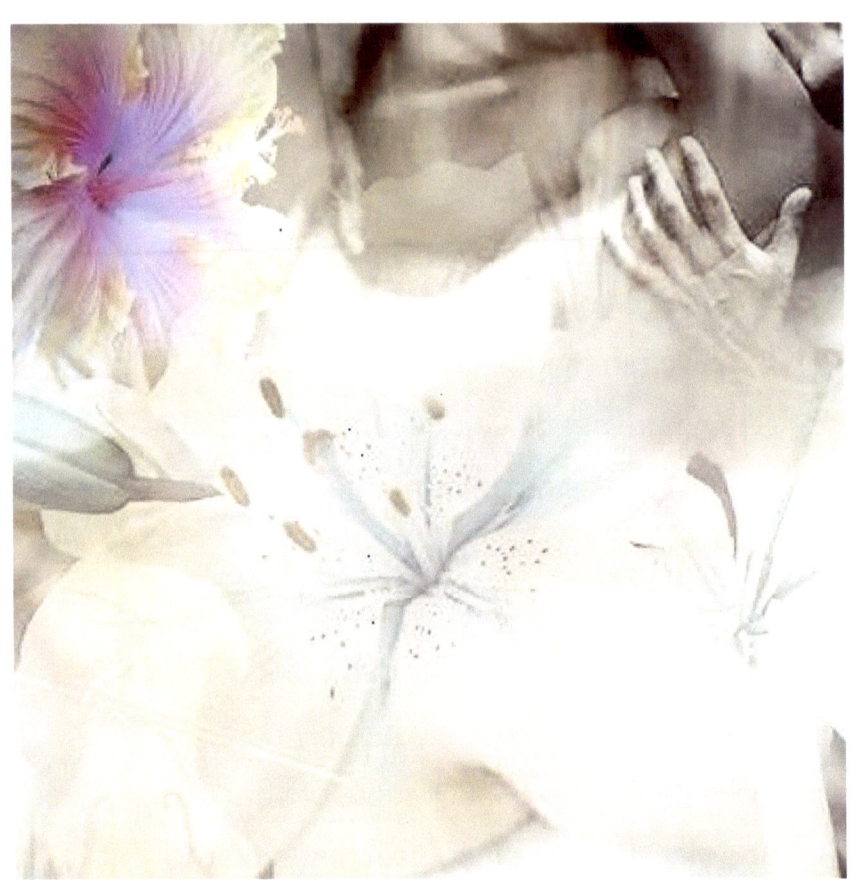

They danced a rhythm all their own

Just feeling the music in their souls

Each song, together, not alone

Their composition, passion, unfolds

Now open to each other's touch

Playing their souls, they do it together

Skin to skin, their bodies clutch

They wrap around their world of pleasure

Showing each other, what nobody's seen

Her flower opens to the sun

He comes in the petals, in between

Their bodies truly becoming one

Their music climaxes in clefts of clouds

They felt, everything, that nature allowed

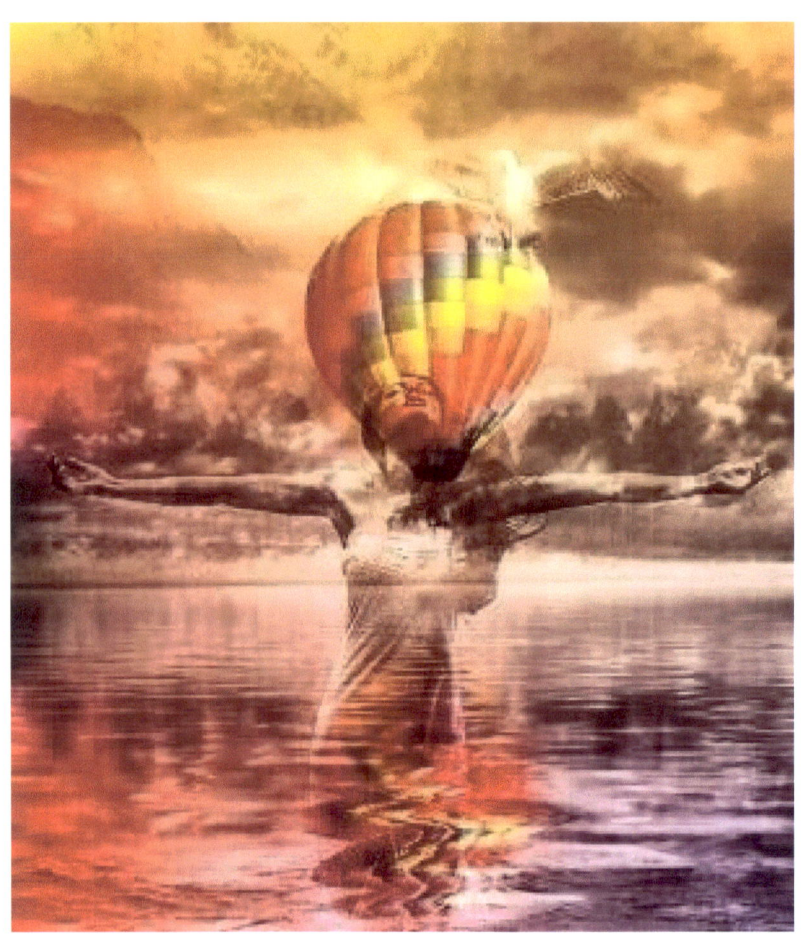

Each day lives so you can care
The players move in all directions
Look to the eyes, know they are there
And know they do not seek perfection
They want you, not the diamonds and pearls
Your soul is the only gold they treasure
When your heart sings, out to the world
They hear it right, in simple measures
The Jones' never wanted to set a pace
They thought the stuff all had a soul
All said and done, all lose the race
Living in kindness was always the goal
Live in dreams, but know your worth
The harmony of hearts, is naked, at birth

DANIEL HENKE

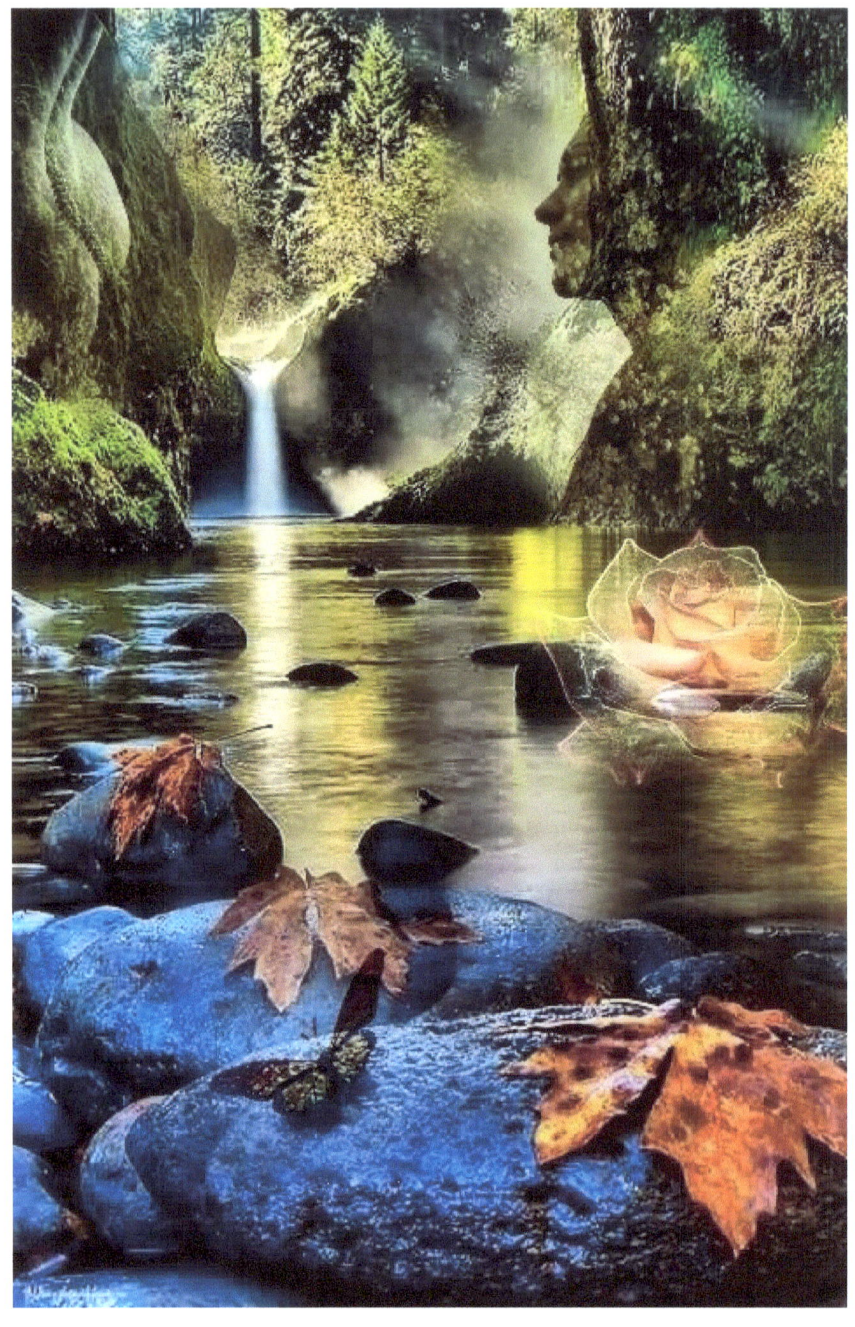

Dream in a scene you think you see

Open your eyes to what, for all, is good

Your wind can sway your knowledge's tree

Life requires nothing, but you surely should

Hold your peace as long as you like

Your piece of this Earth will, one day, move

When parting, Earth stays, you knew it might

You're whole when your sky is the part that is you

Ground yourself by being free

Float your spirit high above water

When drifting, remember, your dream's meant to be

And stability happens when helping others

Pay it forward, commit selfless acts

Humanity's dream: altruistic facts

DANIEL HENKE

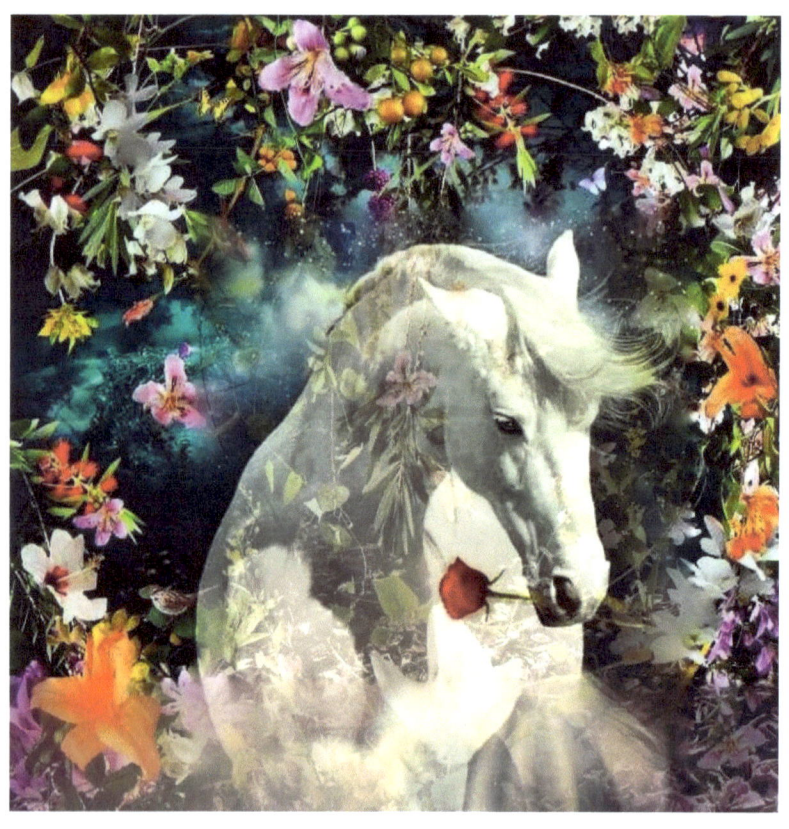

Bouquets of words across and down
Some make sense, you like the look
Others, square, wish they were round
They tell the story in your book
When crafting words and sowing seeds
You notice most seeds look the same
There's always one that meets your needs
That rose you grew just magically came
Almost perfect, but nothing really is
But in your eyes, she's all you see
Imperfections are what character gives
To the beauty within, out, meant to be
The words that describe what nature grew
Picked only one flower, that flower is you

DANIEL HENKE

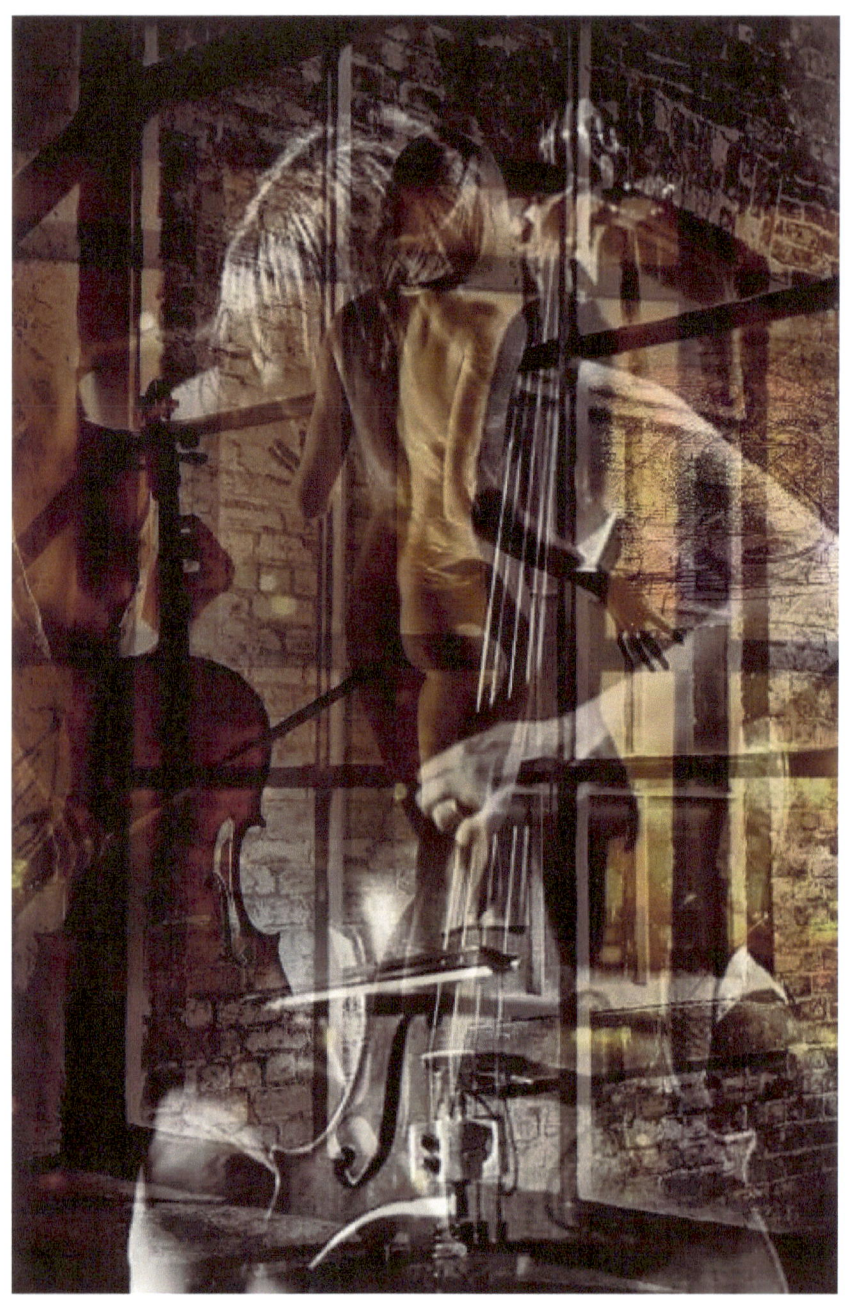

We orchestrate the brightest notes

We play our saxes frequently

Our music books are full of hope

Our sessions played in secrecy

When public, there are undertones

But only we, can hear them sing

Those noises are our saxophones

Fly sexy and sultry, overtone's wing

Wasn't life intended, only meant to be?

A musical that nature enchanted

The charms escape soliloquies

But caught our breath when they incanted

Love is our opus in every stroke

Kneading our purpose in tones that we spoke

DANIEL HENKE

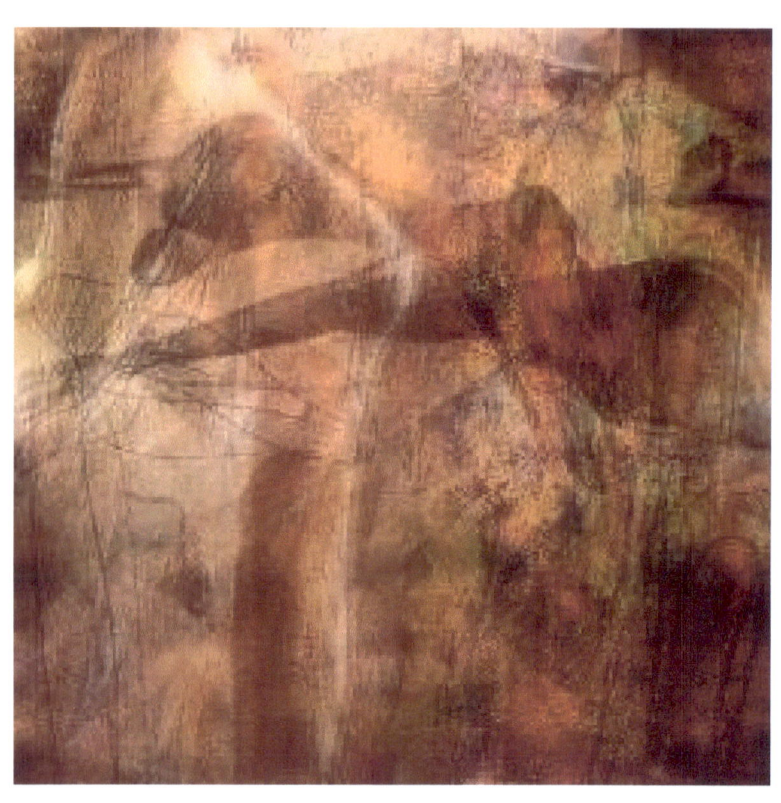

I have some questions, I ask the world

But different answers come my way

Most confusing are boys and girls

The reality found in what they say

Said desire, it fades with time

Burning fires, exhausting their food

While mine, efficient, and feeling fine

For unknown reasons, I'm still in the mood

I am the alien, observing their waves

Eating my honey, this never gets old

Feeling valiant and hoping to stave

The hotness I feel from becoming cold

I wish only passion to live on this Earth

For humans to realize, what intimacy's worth

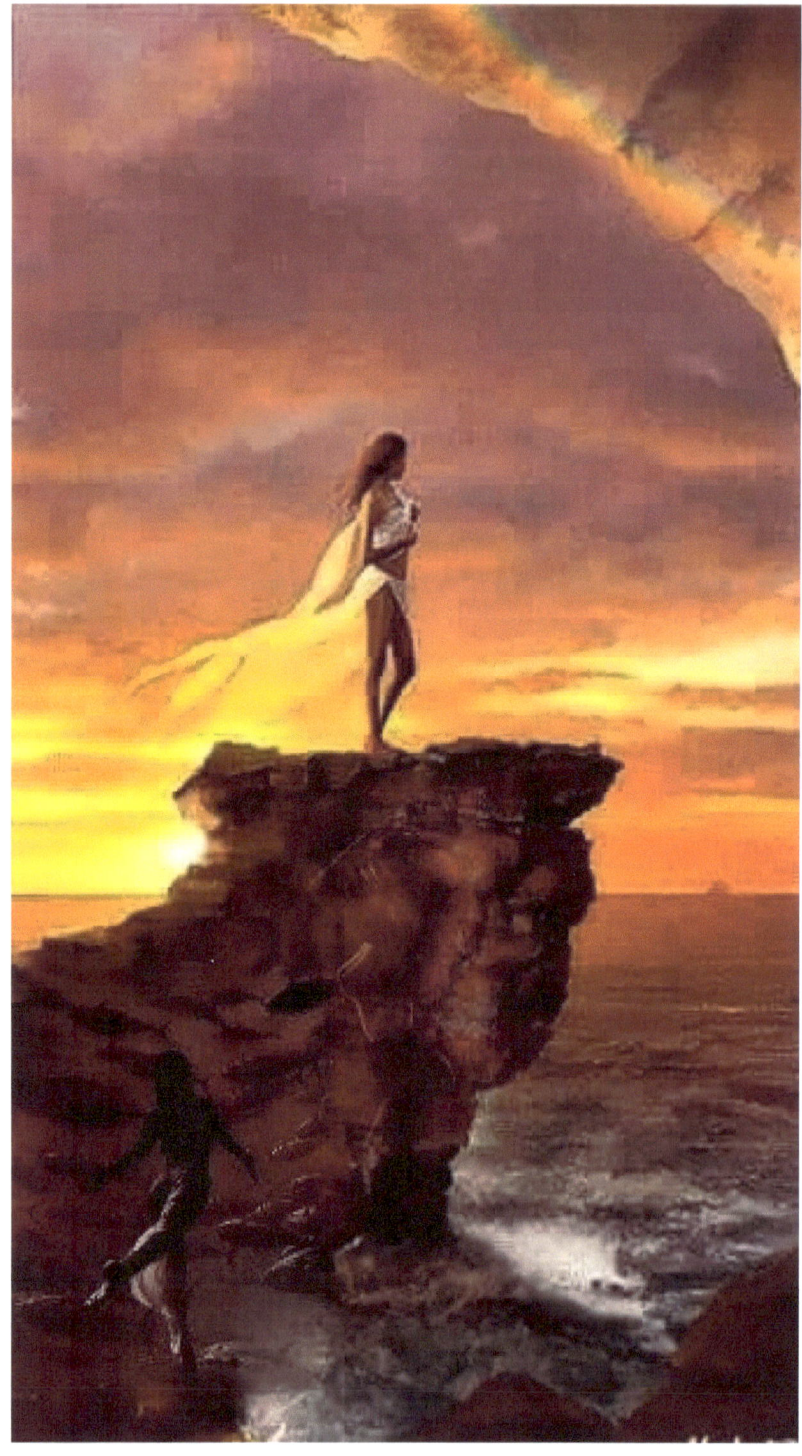

God let me live with a beautiful girl
To let me be in a heavenly place
And every time rain comes to my world
Her sunny smile soothes my face
I lived through times, occasionally worse
Just like the rest of my sisters and brothers
Those people weren't last and I wasn't first
They were just not for me, those other, others
When I was a boy I had no place to hide
My darkness wished for an angel's face
When I discovered that beauty's inside
The beauty became, in every place
Find beauty within your darkest fears
I found mine in my baby, after, so, many, years

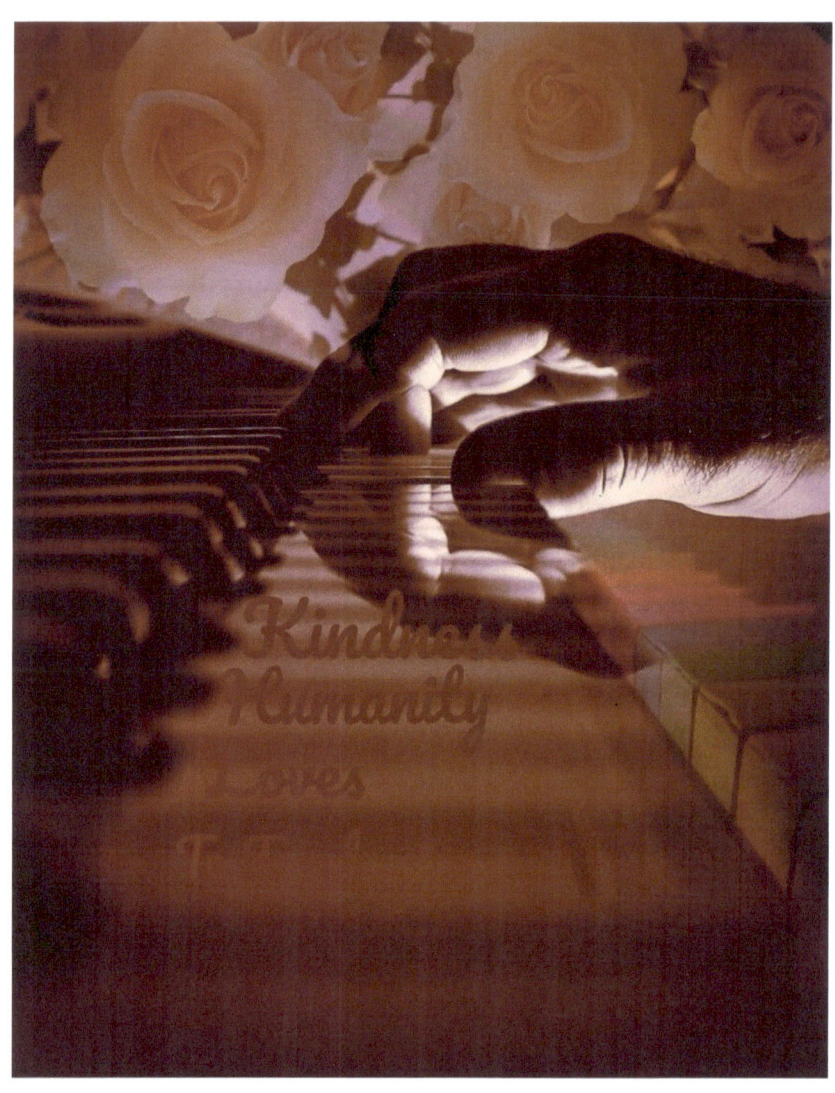

A sonnet is song in humanity's form

The beauty is felt by the eyes that it reads

Conveying a tone, many times, warm

While pulsing perspectives, its vanity bleeds

The words are music, not only to ears

Melody riding in kindnesses' wake

Opening the mind, and staving some fears

We wish for best paths, our soul to take

And then, for the artist, crafting these words

Wishing to light at least one smile

Fed by each spirit, or nature, they've heard

Or maybe just thoughts, from the inner child

No matter the source, words are destined to meet

Like lovers in fact, on destiny's street

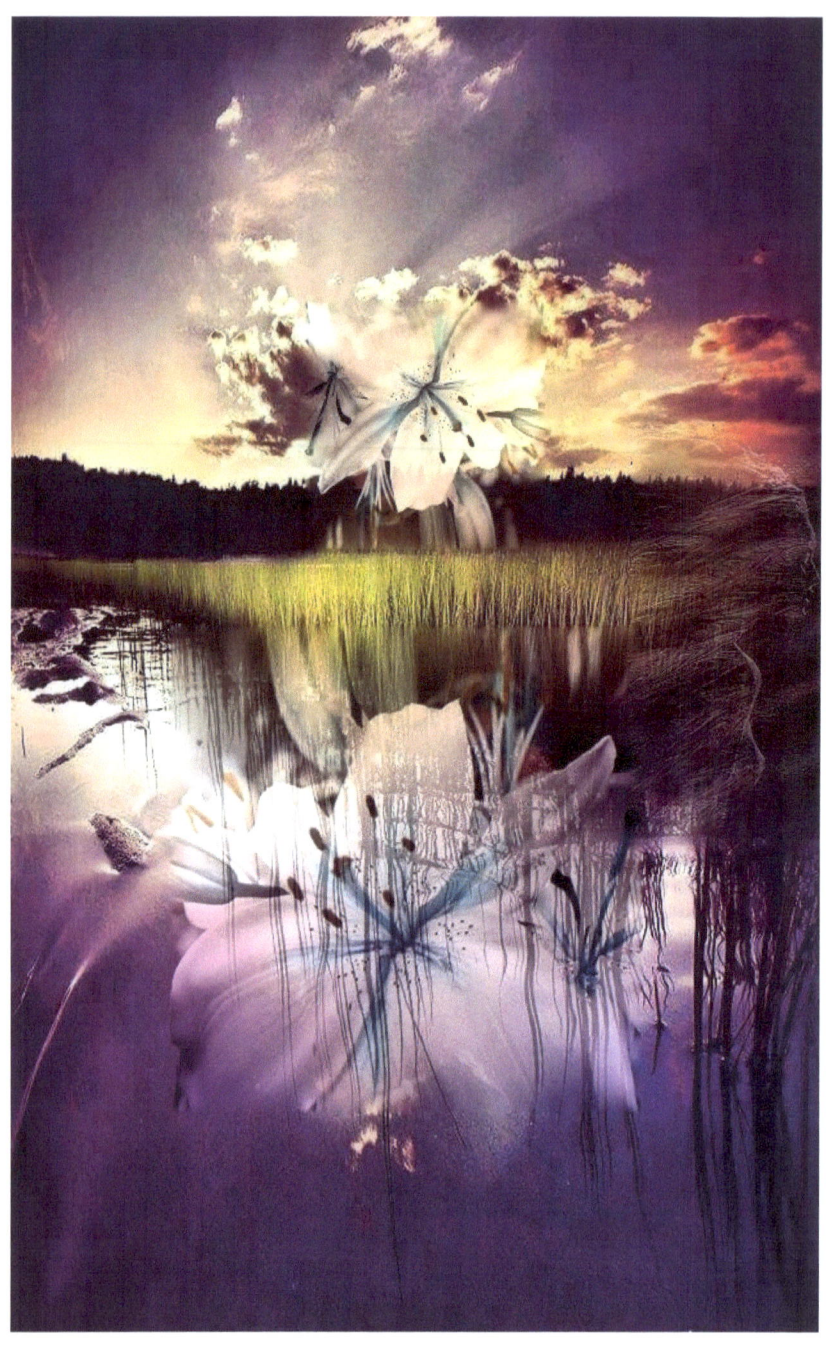

If love is a prize for life on Earth
To win costs nothing, only soul
Each time you love, you know your worth
At times it's hard to see the goal
Kinder words drive gentle winds
Love is for all, not just for one
Practice this game again, and again
Unearth, to show your soul the sun
Competition is so exhausting
Quit the game that most of us play
Kindness pays what love is costing
It soothes all pain, and wins that way
Your dream was always meant to be
A realization, just set you free

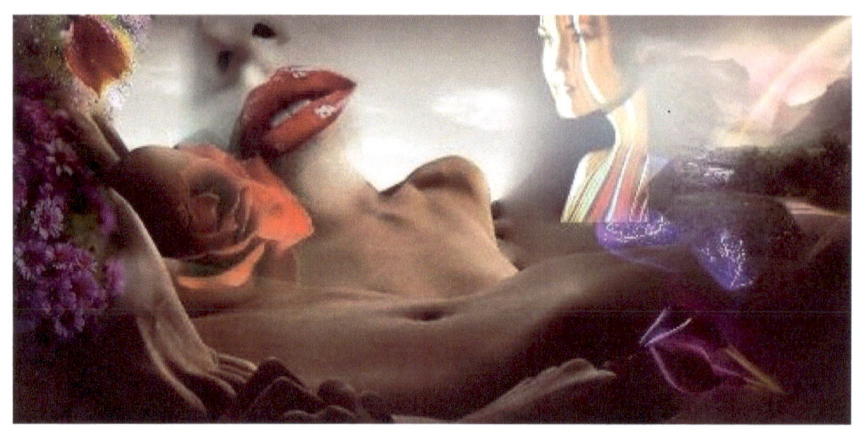

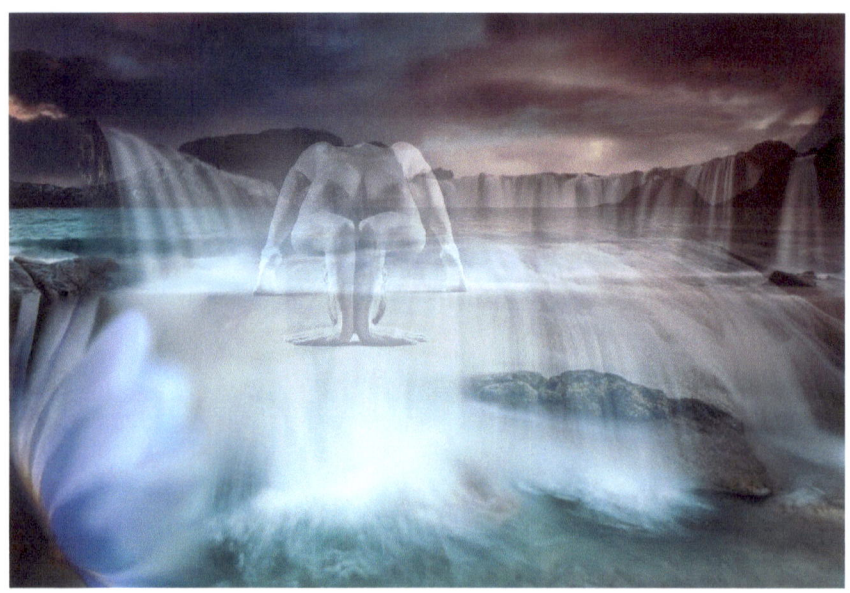

Desire is mostly misunderstood

When fundamentals get placed first

Beauty gets more press than it should

When the eyes of the genders, see only thirst

Animals, are we, it's hard to admit

And as for balance, likely, not

The surface we focus on seems to forget

That simpler needs are what we forgot

Candy, to the eyes is tempting, true

The meat of the carnage, materialistic

Focus your kindness on what you knew

You know that fantasy's unrealistic

Philosophy manages hunger in time

Desire satisfaction, with true love, in mind

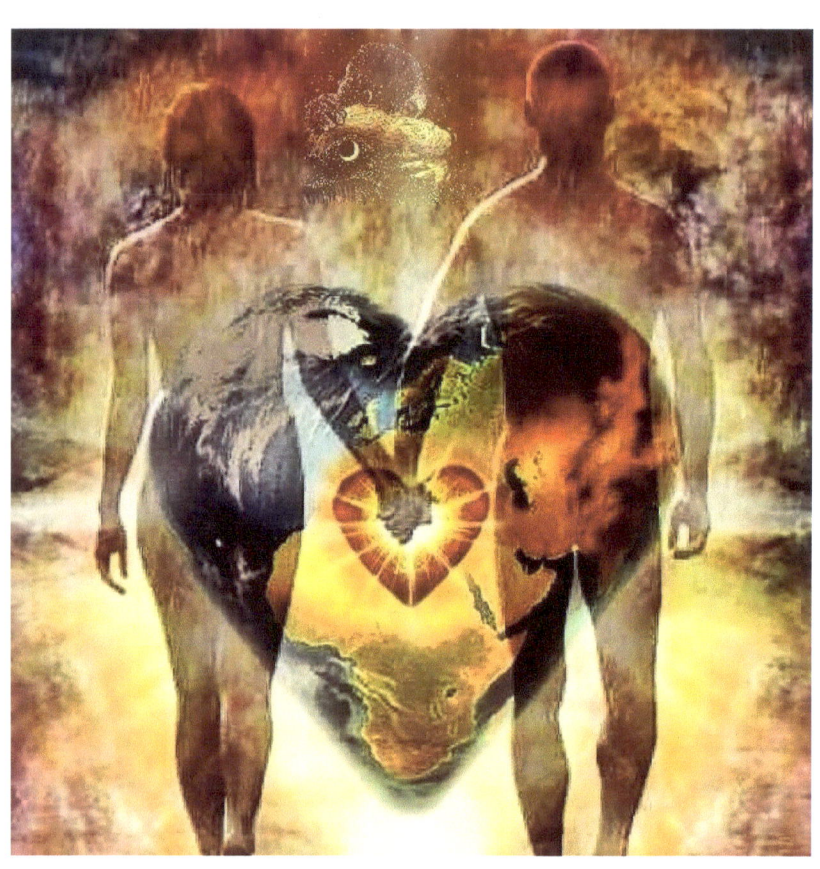

Born of water and raised by fire

Soothing the surface of magic's everything

Two paired as one, they burn with desire

Every time they're together, its love that they bring

Two hearts as one and wrapped around Earth

Two partners that share a common path

Kindness was granted to both at their birth

To others is where their kindness is passed

The world is confusing to the beings so kind

As they wish all the same in life's equation

All other beings, being able to find

The beauty of nature in every occasion

Gratitude felt for this life you were granted

Allows Eden to hold the hand it enchanted

DANIEL HENKE

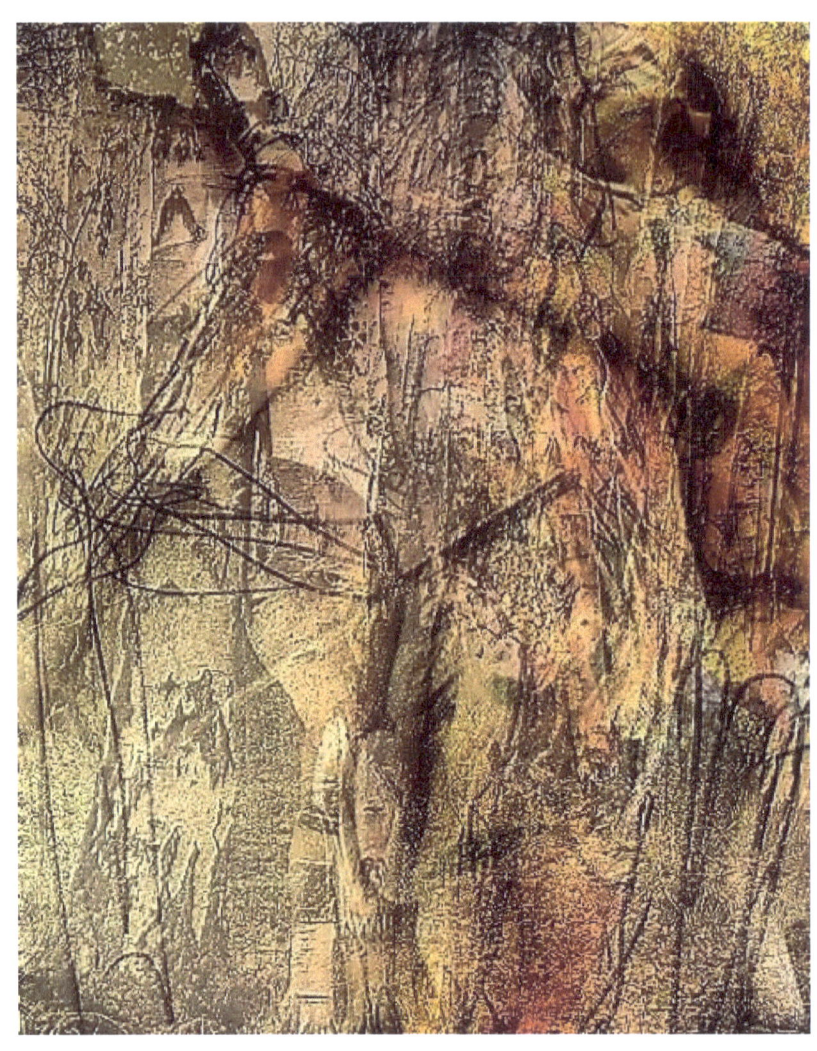

What do you see and who do you feel?

Shapes, the artist hides in lines

Finding the meaning makes it more real

Where will you go and what will you find?

Look, into the surprise you might get

Maybe you'll see what you already knew

After all, you know more, than you let

Did you ever consider your artist is you?

Paint your life within your mind

Focus your wishes from your fondest dreams

The more you close your eyes, you'll find

That world of you, amazing, it seems

Inventions within, the true artist taught

The colors and lines, you study, you ought

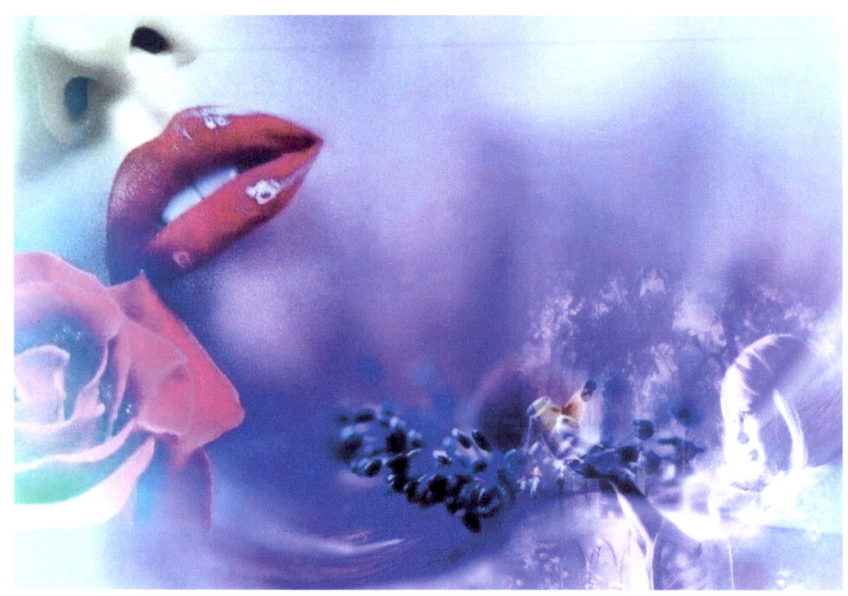

Sometimes we just don't know what to say

But a touch and a smile can spark

Comfort and warmth in tender ways

The right thing to do, right on the mark

Together we stand while sitting down

Strength drawn with pencil, not pen

Emotions dressed to go out on the town

Lifted in arms where the strength has been

Older babies smile much more

Watered and fed with better food

Choosing better than they did before

Knowing emotions, controlling their mood

Humans' babies are the child within

All of them know all the places they've been

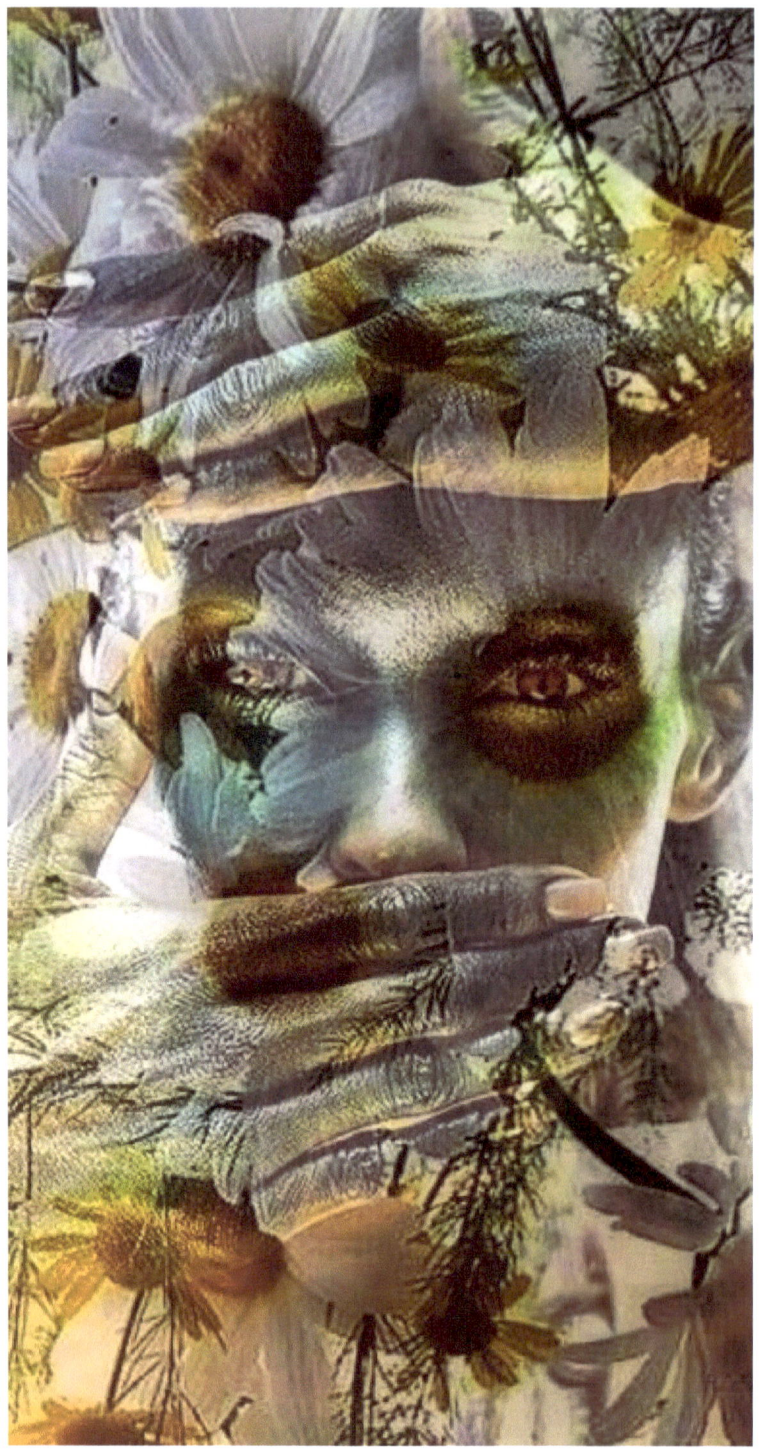

Thank the truth for what you see

You see things different from the rest

Nothing's really meant to be

Anything less than your very best

Avoid the norm by painting faces

Looking for visions never yet seen

Show the world the other places

Those that place them into dreams

Dreams are where acceptance is found

Floating past the critical eyes

Dreams are where the truth comes down

Because there are no alibis

Honesty is a choice you make

Show yourself the truth you take

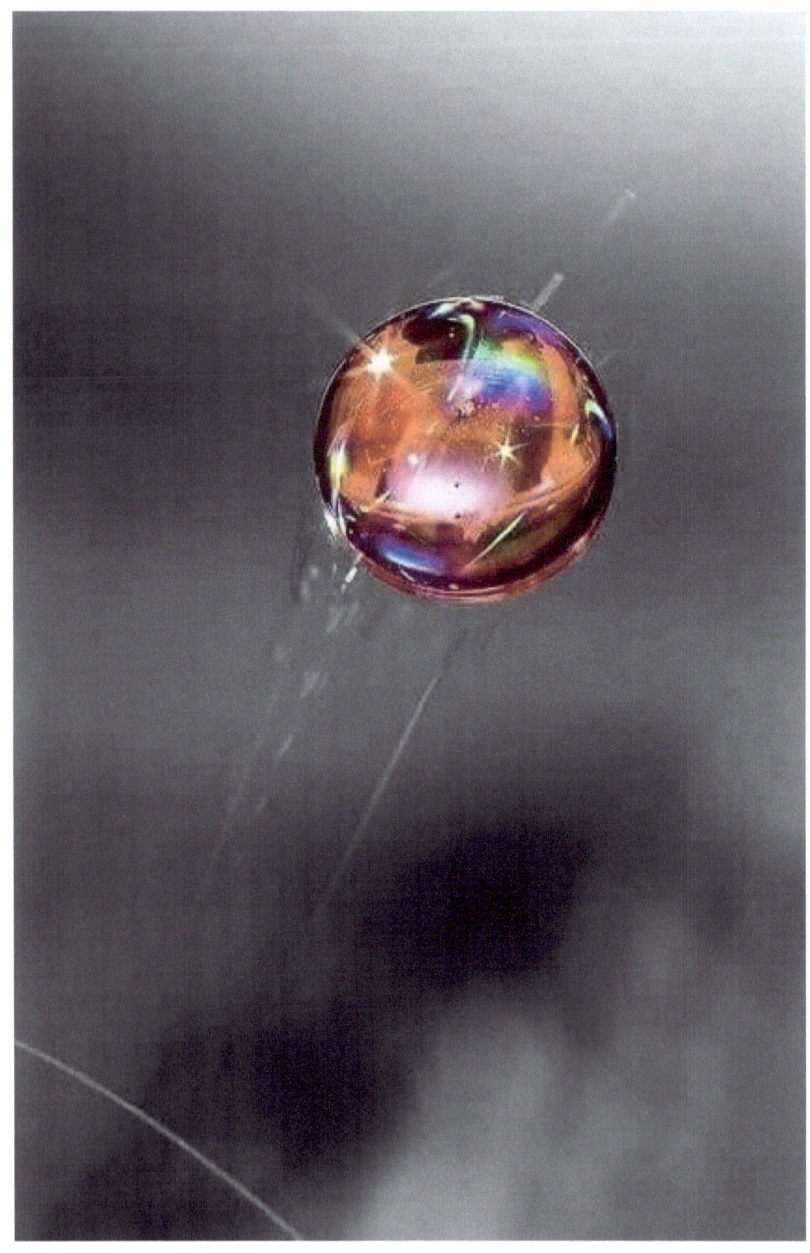

Every day comes new and sees

Different magic, thrill of hope

Learn to see beyond the trees

Beyond the green, beyond the globe

Your soul and spirit fly through time

Ignoring all its complex rules

Energy that draws the lines

Between human myth and spiritual truths

Help someone today, and know

That paying it forward helps the cause

The cause that helps our spirits to grow

Beyond all rules, defying the laws

Giving of yourself, in time, you learn

Not to expect, anything, in return

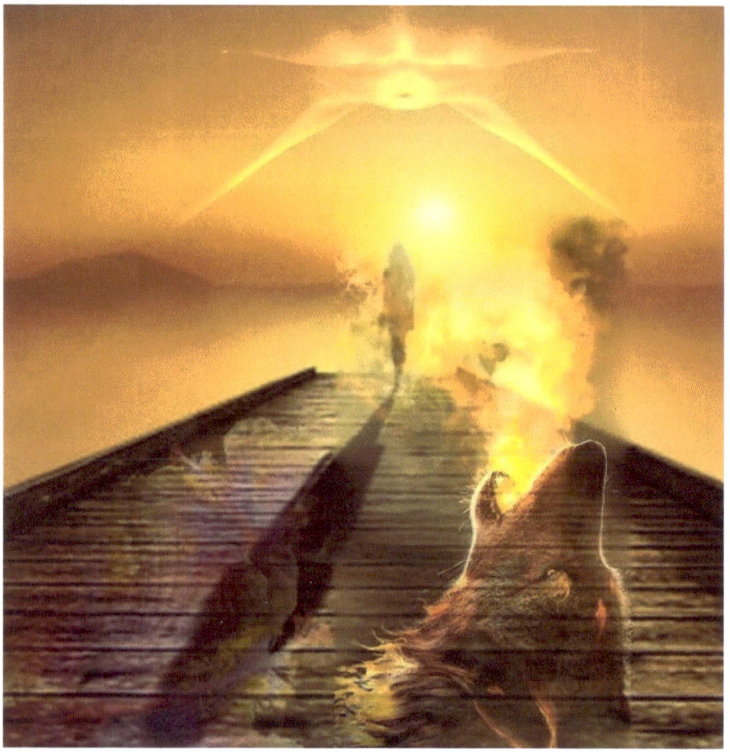

Emotions are spirits, energy experts
Their language one of sight and mind
They are the patterns that life exerts
And lead us to the peace we find
No need to ask them for even one thing
They share energy without request
The subtleties in dreams they bring
Give us sleep and guide our rest
If looking for a spirit to see
The shadow cast will show you all
Black light has been their reality
When emotions can't be drawn at all
The shadow cast by nature's light
Shows we're here, till souls take flight

Famously-minded, are those that write
Words that are heard, seem more, to matter
Most, written to soothe, but sometimes fight
With power, some words, can also shatter
So many writers of word and song
Trying, at least, to gain notariety
Trying, to prove that we knew all along
How to inspire, some say it's piety
Humble, are we, our drive is unknown
Our minds tell us to write it, now
Then before it escapes, we claim it, to own
We created our words without knowing how
Creativity; it comes and it goes
Just where it comes from, we'd all love to know

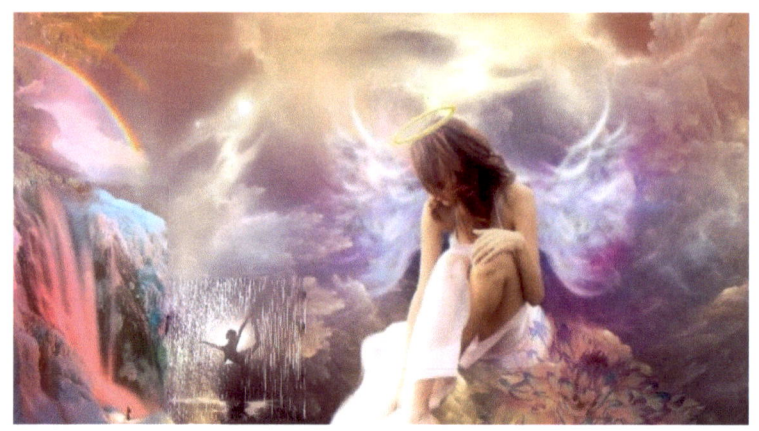

Afraid of the dark, I held my own hand

Encouraged by subconscious eyes

The conscious light will understand

The heroes' unsaid alibis

Courageous minds are said to be

Unencumbered by any fright

Smiling at fear they fail to see

Disadvantage to conquering plight

All have fear but some have faces

Not feeding it but walking through

Those guarded, not so scary, places

My inner child said it knew

Fear is in the beholders eye

Reward beholds the hands of night

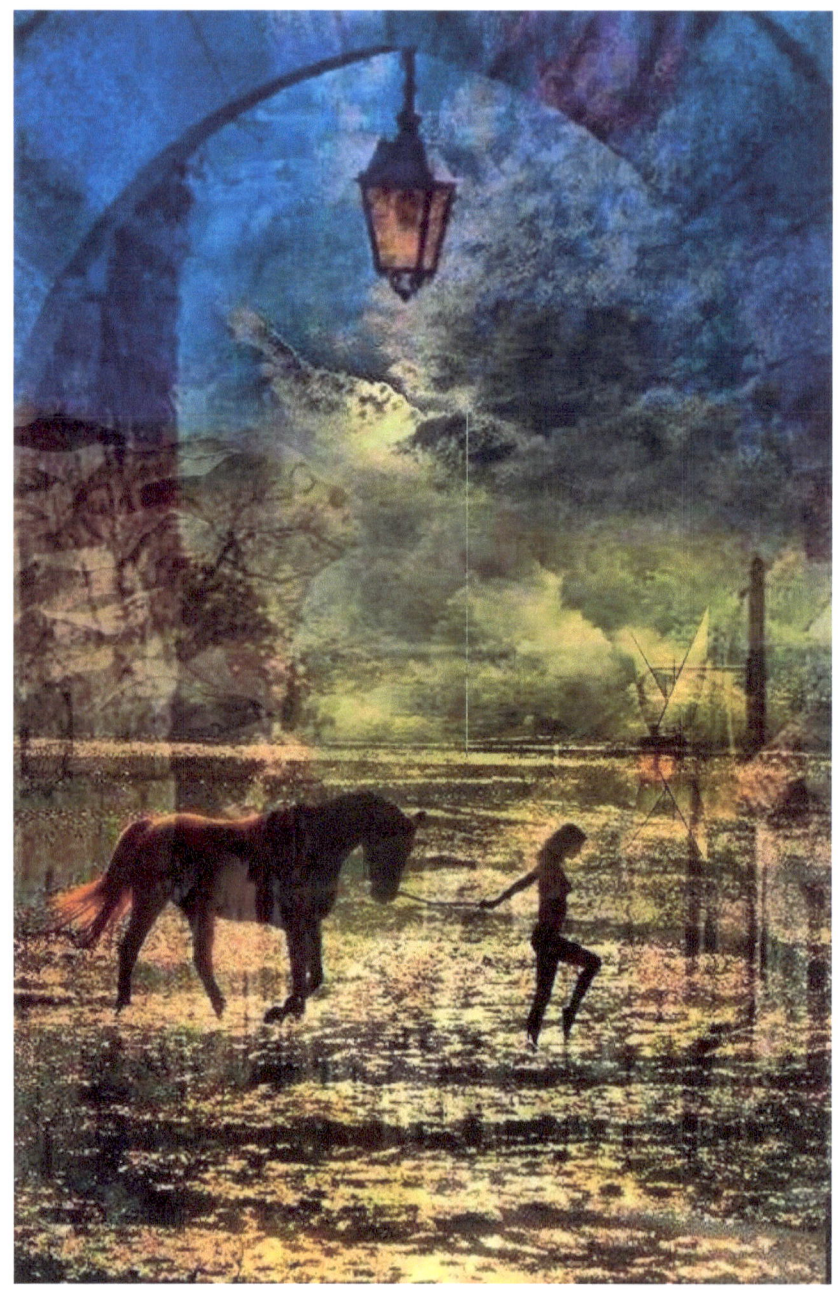

Beauties and beasts they say we are

Sharing a world with one another

We've come to now, we've come this far

With her to thank, our nature's mother

Greens and golds paint beauty's arch

Grateful for all the awe we're given

All the creatures playing their parts

Of roles respected and vainly forgiven

We live in peace and side by side

We play together in scenes of wonder

The challenges, we take in stride

The sky, the roof we're living under

Some humans see a different peace

And realize the sameness; we too are beasts

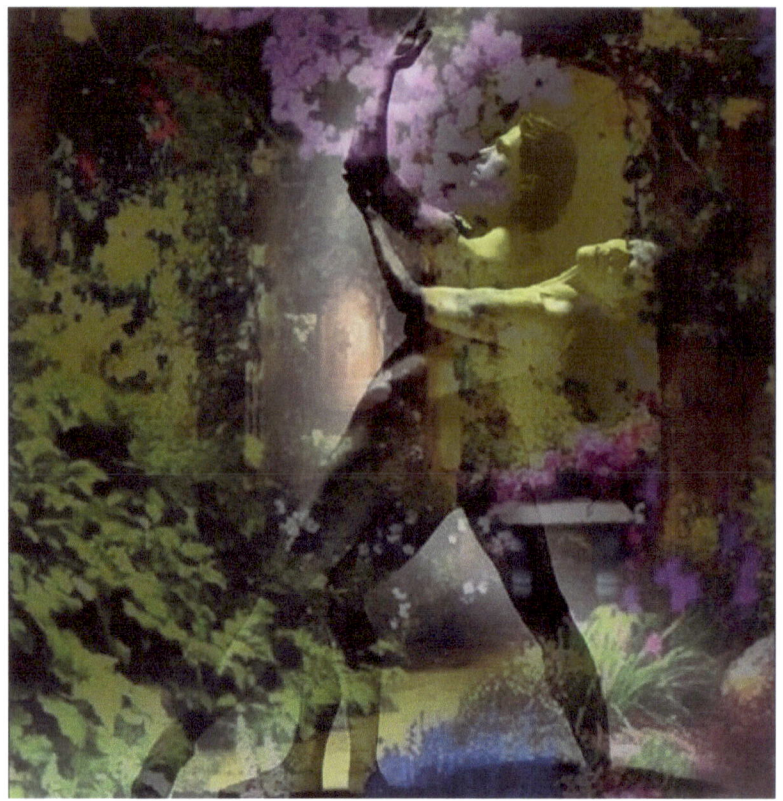

Don't doubt the height to which we soar
There is no ceiling beckoning
To others, Love's a fabled door
That opens to a reckoning
We find plateaus each time we walk
Every time a different view
The more we bond, the more we talk
The more we talk, the more you're you
We ask ourselves the meaning of height
Like if there is a looming limit
We tell ourselves we know we're right
We're living love, we know we're in it
I sang a song and then you smiled
You're what he saw, my inner child

Sakayume

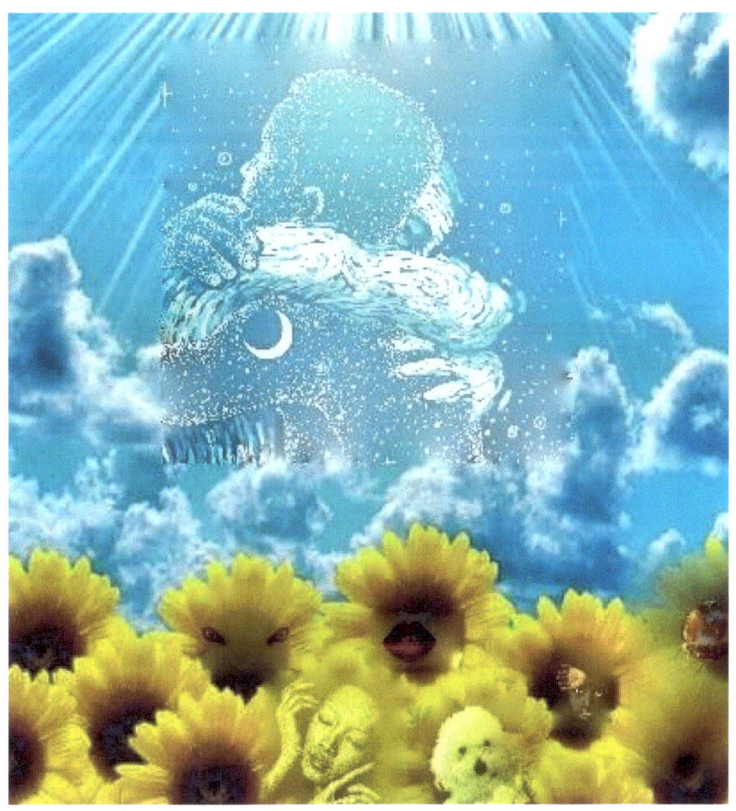

Grains of blue show sky like sand
Eyes are fooled when sun lights blacks
Human's rarely seem to understand
Nature's amazing energy stack
Held in a circle, our eyes can't see
Past the blue that lights their day
But at night revealing infinity
Their minds, for comfort, slumber away
Energies of nature all shine
They show their power for all to see
Expansive space defeating time
Living off crystals' energy
Theories of how our lives were created
Escape this wonder that's understated

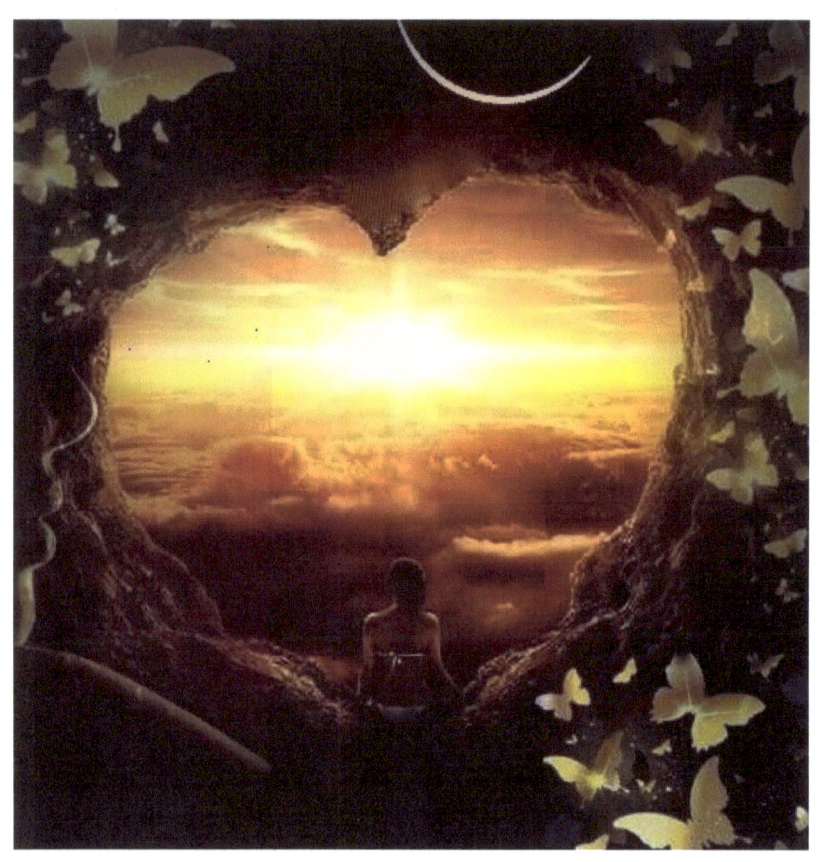

Eclipsing the colors that paint our sky
Excitement held our hearts today
Silhouetted our butterflies
Instead of a moon that got in the way
Our stars are paths from here to there
Showing a path, but not telling why
The path that seemingly goes nowhere
Is often the path we wish to try
The future uncertainty took a vow
The definite terms not playing a part
Decided the best place to live in is now
While the future is writing the songs of our hearts
The butterflies live in the future you see
Transforming our visions to fantasies

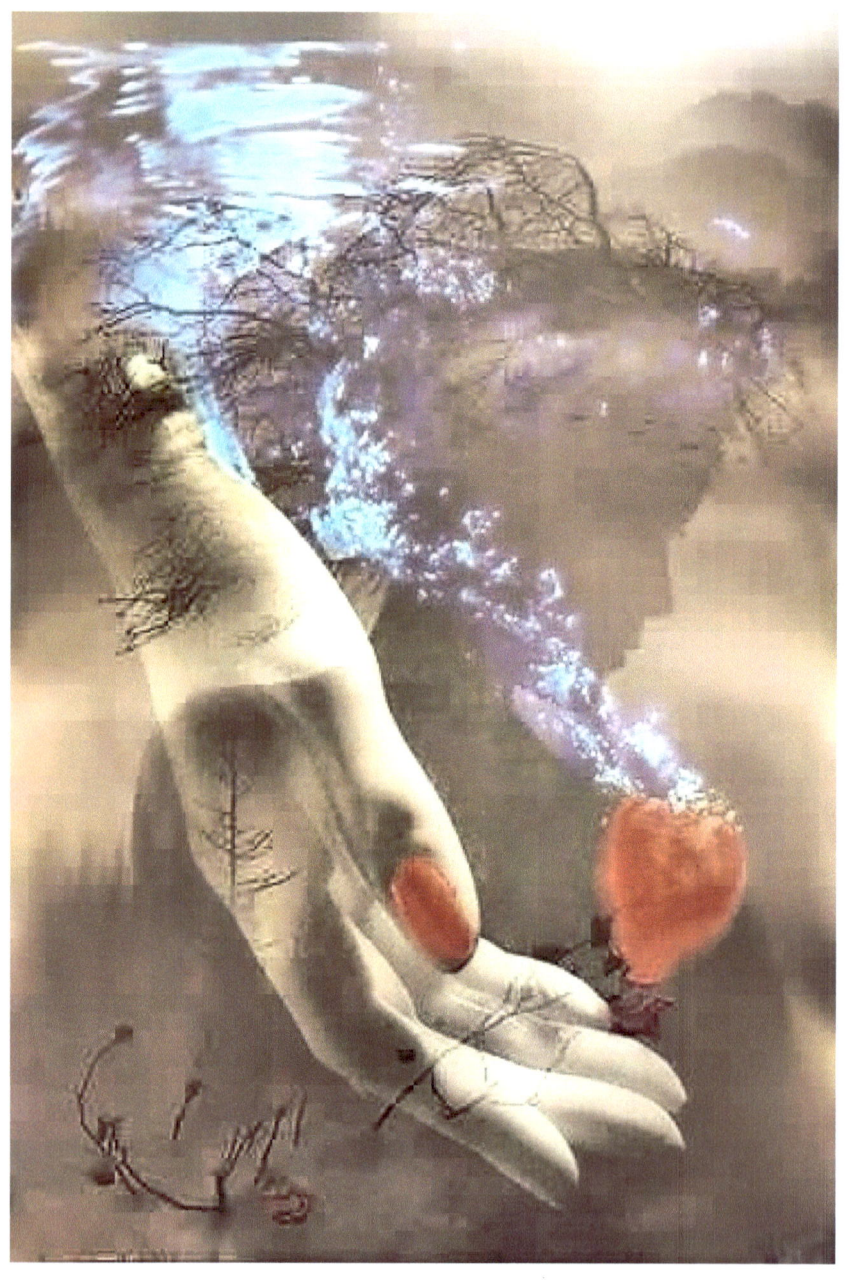

Swimming in a mind at bay

Floating in a buoyed life

Thinking in a subtle way

Cutting edges with a knife

Gravity is enlightenment's friend

Softened edges feel much better

Find the means to tie the ends

Storms that break some strings of weather

Life rewards those who endure

Accomplishment is mountains' majesty

The day will come, we can be sure

Antagonists fail avoiding tragedy

Honest words aren't always true

They float the mind during murky blues

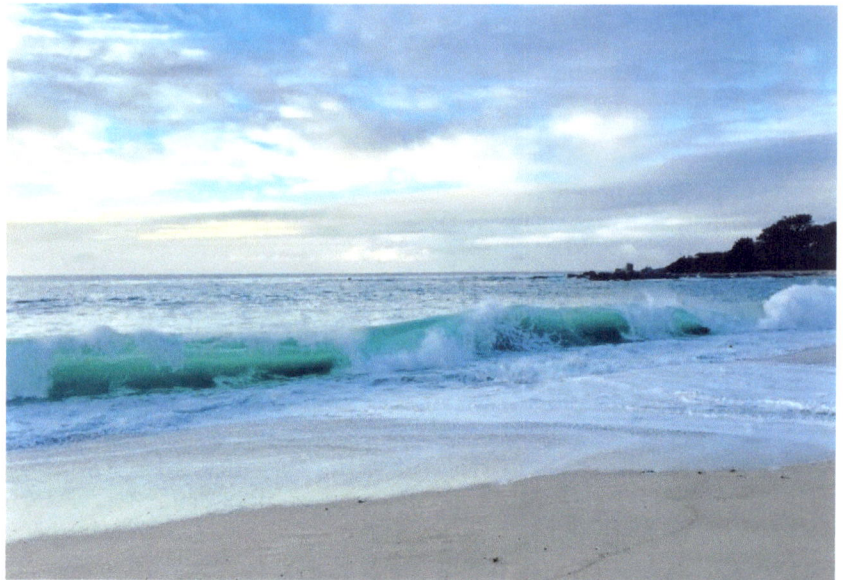

Rolling waves inspire your mind
Sitting by the beautiful sea
Senses, five, invariably find
A sixth, sometimes a fantasy
How long do you think it's been this way?
Think of the waves, they never cease
But you saw just how they fell today
And broke some tension, in sweet release
There's a reason people come and stay here
Wondering in now, how they came to be
The beach is a place generally void of fear
And governs with power, but quietly
Imagine the thoughts of the millions there
All of them awed, all of them stared

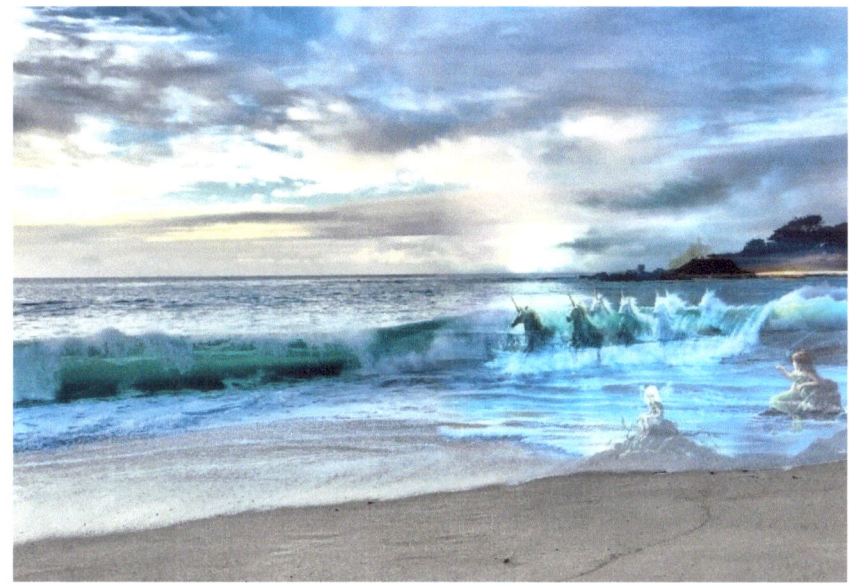

Rolling tides of crazy horses
Unicorns we wish we could see
Open your mind to feel the forces
That pacify souls, ever, endlessly
Mysteries draw a magic scene
On every beach and overlook
The imagination's in between
The words that love wrote in story books
Human's write the books, by seas
Their inspirations' sources, unseen
Of gods and angels, passions tease
Creating wonder with their routines
Visit the shores and breathe the air
A plethora of peace is waiting there

DANIEL HENKE

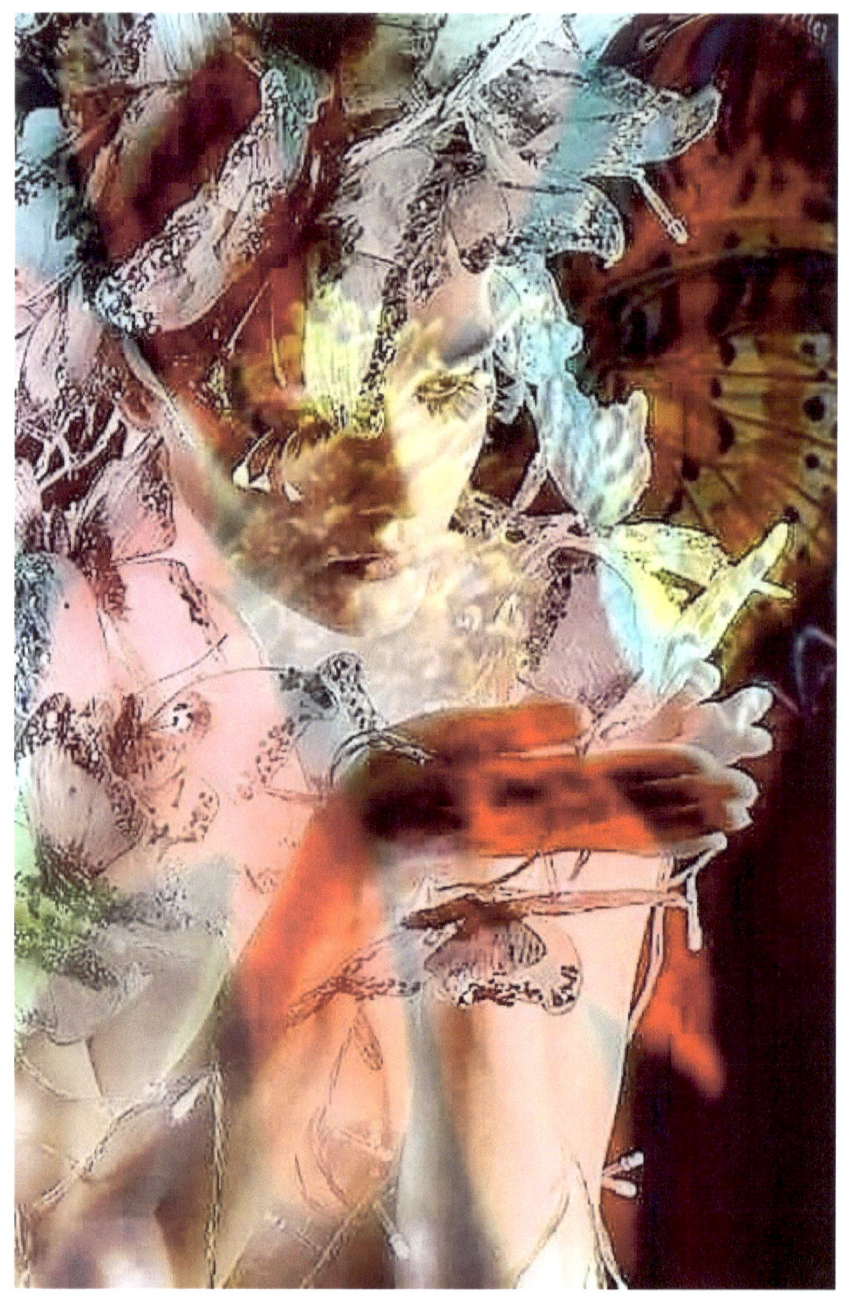

Sea deeply into your upcoming dreams

Before you commit, to go there, to stay

Nothings, really aren't, the thought they seem

But your vision pulls you there anyway

If you see a fear you need to face

Then go prepared by gaining strength

You can choose the time, and maybe, the place

It's harder though, determining the length

The ones you love believe in you

You can choose the ending, it's yours to give

But on dreams' path, adhere to the truth

'Cause stretching the truth is no way to live

Face one at a time, alone, or with lovers

Then after that dream, go navigate others

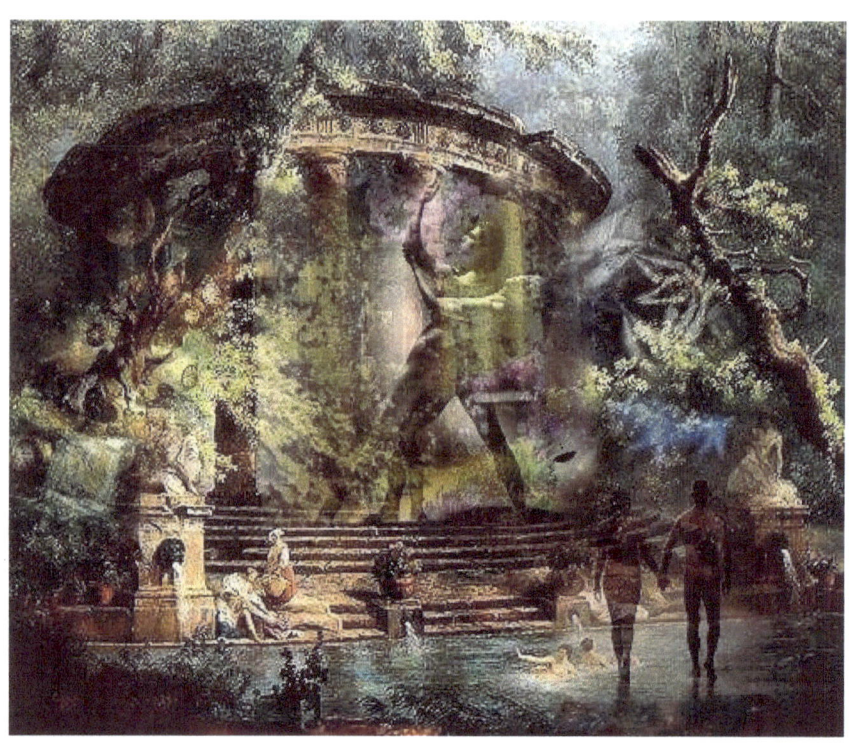

Love promised to run a way with me
A path promised only to lovers
Falling out to faith's vulnerability
Placing my trust in one, plus one other
Love promised a secret souvenir
Knowing whole wide worlds of prizes
It listens to the words we cannot hear
Forgotten words that masked their disguises
Our world is clay, within our hands
Seeing us naked, as nude love is true
We hope the others can understand
Just seeing one, but perceiving two
Joined together, we, inside humility
Our love can do anything, with our ability

Memories of passion, close your eyes

Remember the greatest pleasures

The hope you dreamed between the ties

Of moments we cherished together

The passion created, was, oh, so hot

Destiny painting a passionate sign

Sensations we wish we never forgot

That feeling, remembered, comes, in good time

Now older than yesterday, exotic memories

Just like the ones that inspired you

You, and me, what we aimed to achieve

Each other's fantasies in glorious view

Passionate hopes for our blooming promises

Scent our moments with pleasure and happiness

Friends ask friends for their advice

Good, or bad, does not define it

Almost like you're thinking twice

One and the other, a perfect fit

Always accepted, their vision, a given

A mix of two eclectic stews

It's fun to watch the friends just living

We're entertained, and our minds, amused

They're having fun, it's all they know

Seeing each other, and living in now

Where they've been is where we go

After they just showed us how

Friends trust friends, that's how they show

Examples to follow, directions to know

Crazy thoughts surface, and stir

Some are hidden to keep control

Lines can't see reality blur

Directions of a troubled soul

The color saves us because it's true

There's always a way to find your way back

Like bread crumbs, but they're pieces of you

They keep the mind from fading to black

Light the dark, to show it is safe

It's simply just a state of being

Craziness is sometimes okay

To make sense of the world you're seeing

See what you saw in that blot of ink?

See what you like, and like what you think

DANIEL HENKE

Storm of nature came

Bathed purity in light

White angel was to blame

For avoiding this dark knight

Cleansing the naughty dreams

Cleansing of vanity's fears

Mustering the means

To harvest sinful years

On top of the elegant globe

The truth is rarely told

Of paths of the angel's soul

In context, she never grows old

Seen in all purity, a very kind place

Said fables, were loving, a very kind face

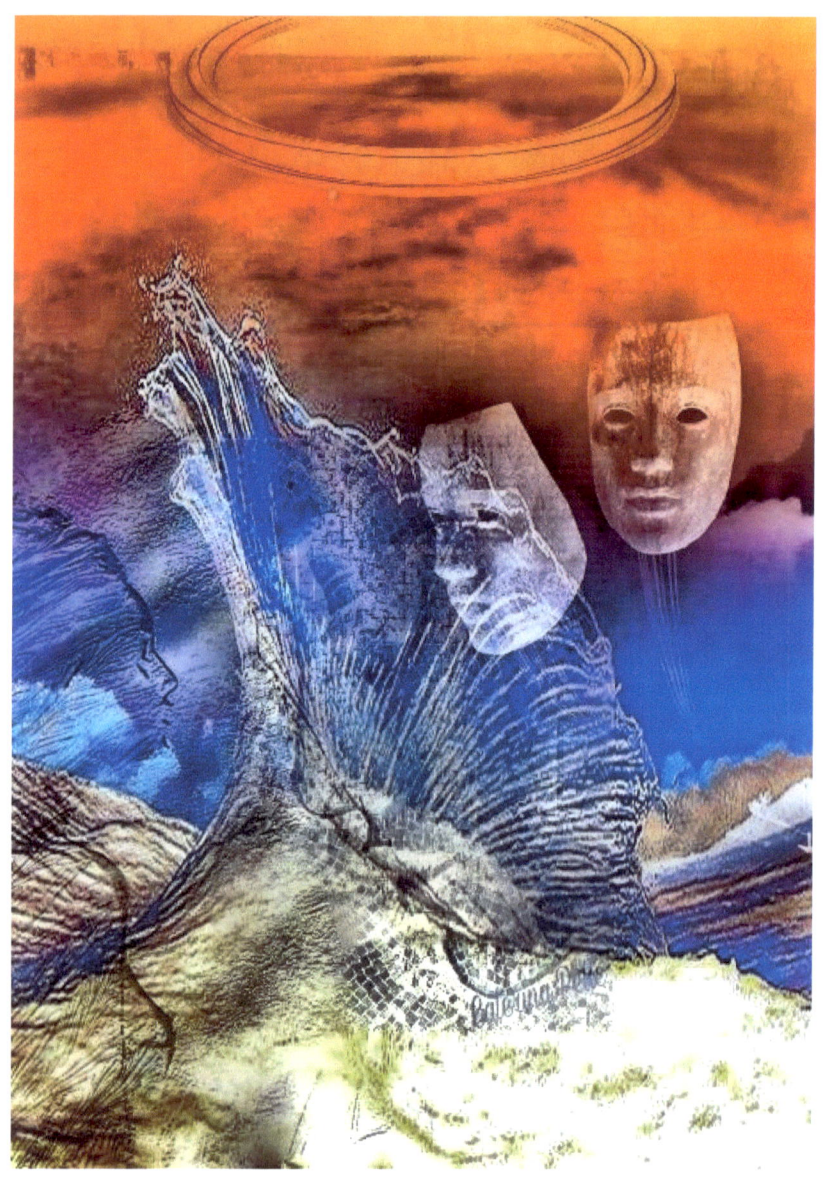

Close your eyes and see only dark

Open your mind and you'll see the light

Reality's truth is truly stark

And accepting kindness is always a rite

Confusing are dreams when eyes are closed

Somehow the light's still getting in there

Choosing your path, you can't see where it goes

Running in circles gives you only a square

Dimensions of time were created by humans

The big ones really impossible to measure

The sun at times being measured in lumens

But never will find the rainbow's treasure

Enlightenment's icon can't be defined

Yours may appear to be different than mine

DANIEL HENKE

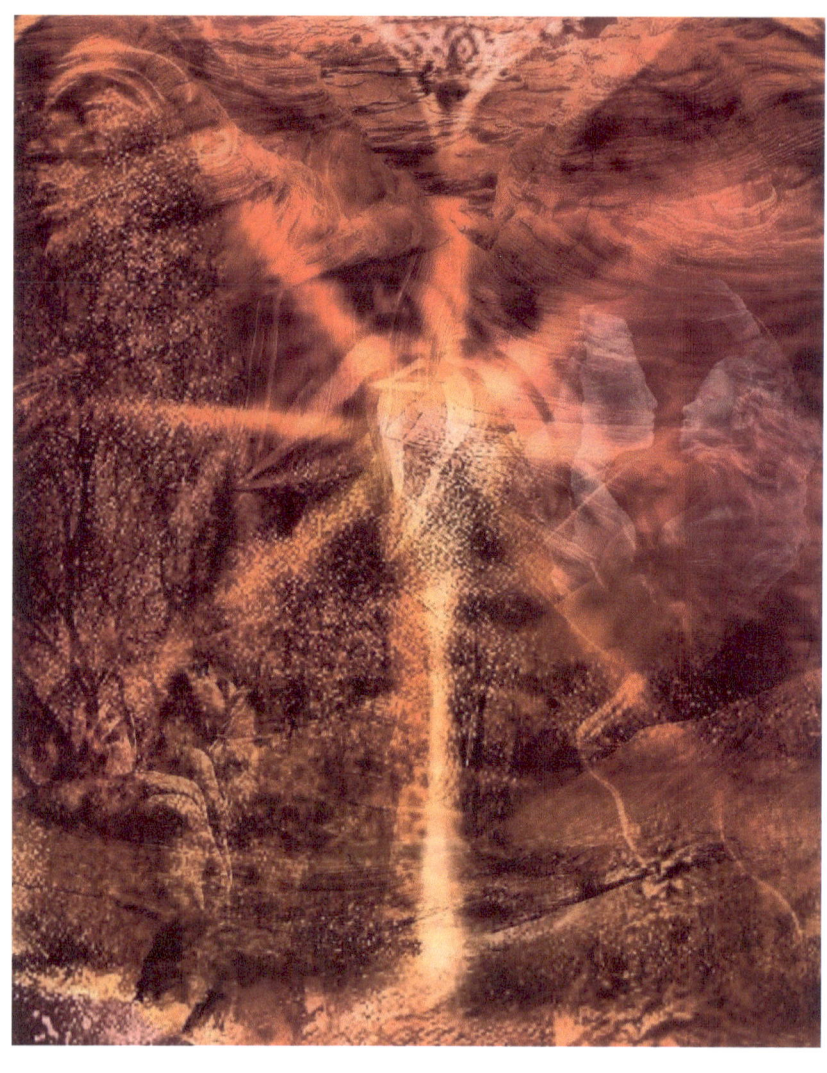

Castaways in moments, our time

Aliens to cultures riddled with fleece

Woven borders, nude under lines

Disallowing to cross, but all known by each

Our borders crossed our hearts with truth

Our fingers moved in sexy ways

Penetrating defenses, but staying couth

Islands of pleasure in a hammock that sways

Why would we shy from endless soaring?

Horizons, sunsets, clouds of love

In beds of nature, it's never boring

Going down on each other, then rising above

No sheets are needed when truths are bared

No limits are needed, we crossed, we cared

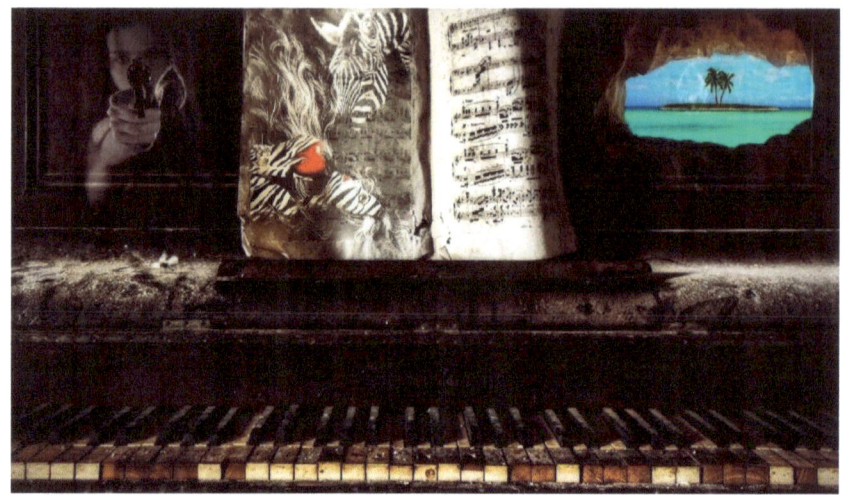

Here lies the truth, a perfect rest
Lies explode up in the sky
Angels note our worst and best
Free will's confusion asking why
Close your eyes, rest your mind
Peace becomes the pattern you see
For all the love of humankind
Truthfulness was meant to be
Fear of truth, that equals lies
Accept the truth without delay
Avoid creating alibis
Pacify your ocean's waves
Stand and deliver, a phrase redefined
When passion's truths, nourish the mind

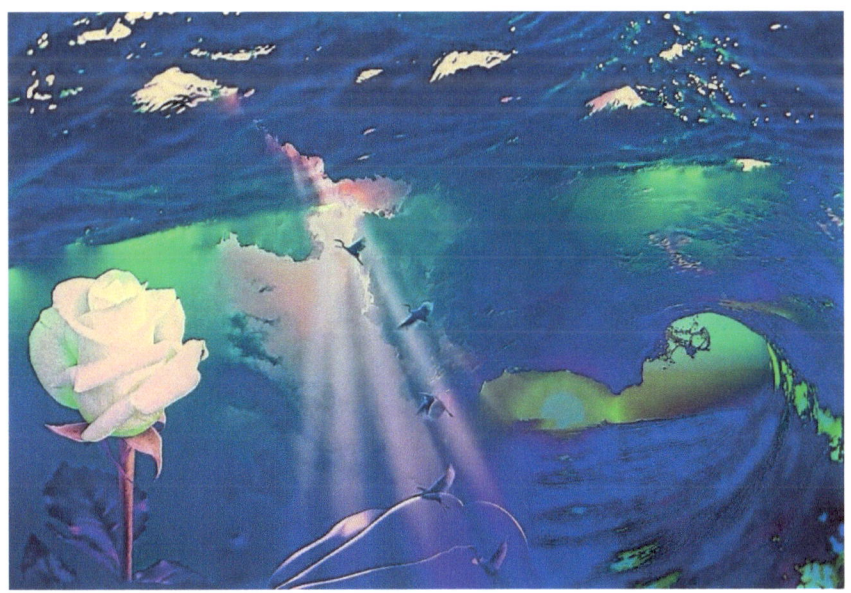

A boy could draw effortlessly
His mind could see what most he wondered
His vision's sixth sense, invariably
Steered to the water, a fantasy, under
Safe, without sound, under water he felt
A woman's form appeared by light
Naiveté made the water melt
His ultimate art, was love at first sight
Boys wish to explain their animal's tension
That melts their manners, clear away
We can explain the things that are mentioned
Inside our lusty minds today
While imagining beauty, even artists see
The form of a woman, inviting, is she

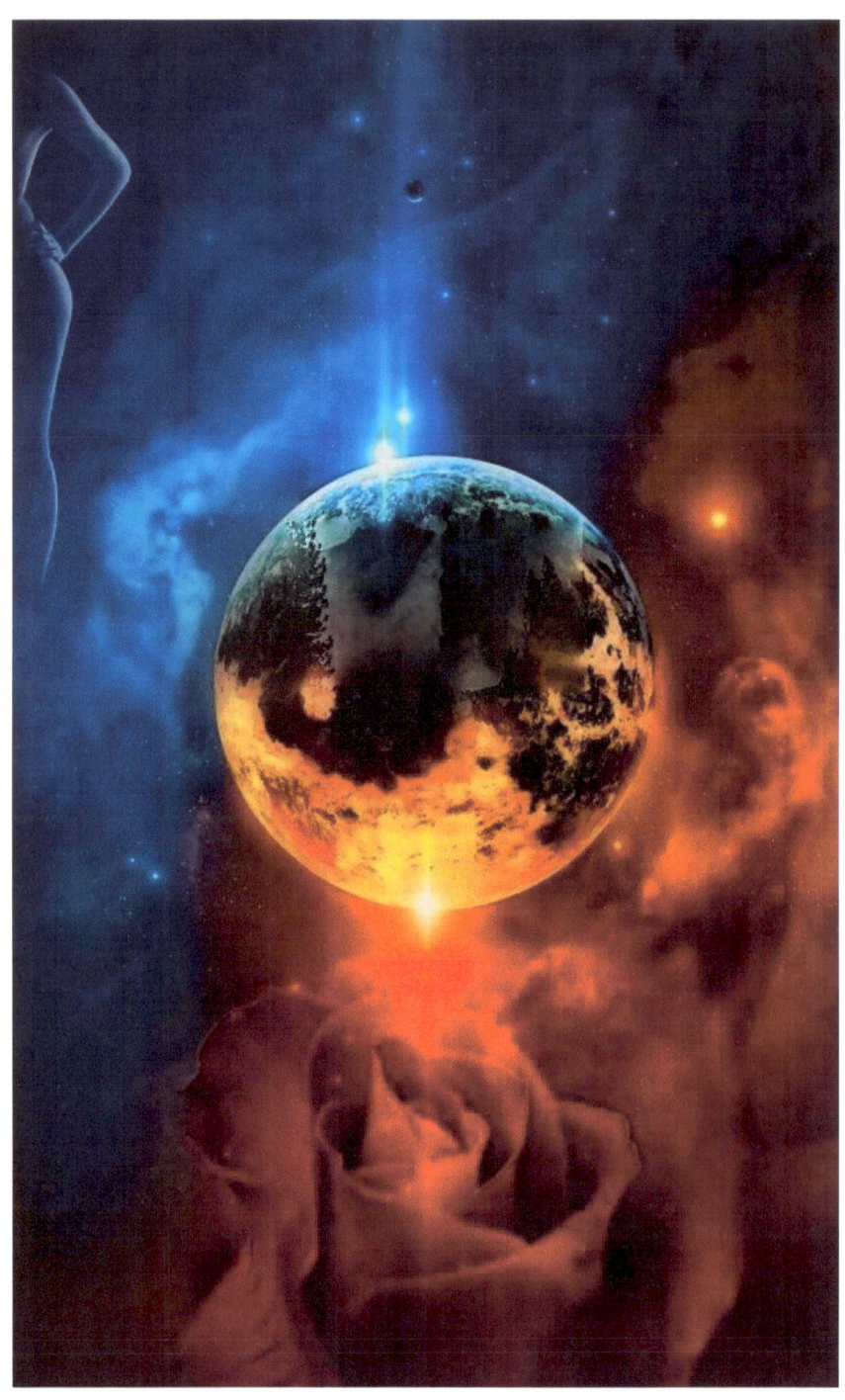

Dimensions science can't define

Belong to love, its definition

Not limited to humankind

Mostly live within cognition

Touch and the warmth make it pure

Opposing boundaries set by some

Takes paths it wants, and yes, it's sure

The mind, excited, when touch is welcomed

Most eyes close to savor pleasure

Spirituality thrilled, both mind and soul

Dripping energy that can't be measured

It's here that all dimensions fold

The reason your sex just loved this reading

Is the reason you should consider conceding

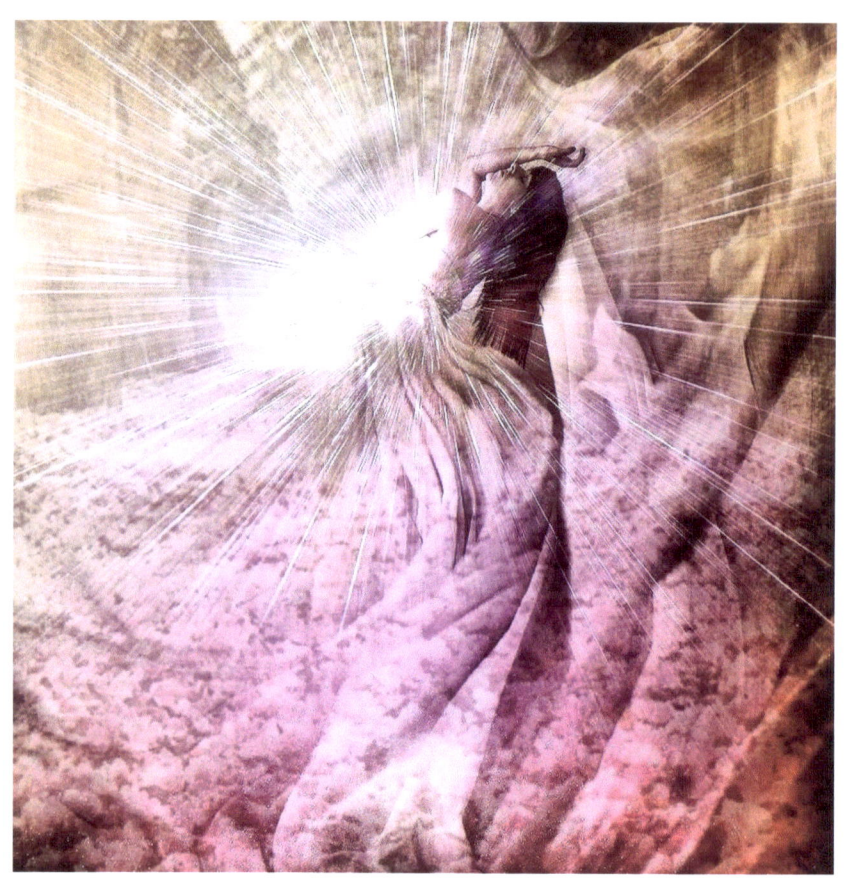

If you choose love, you get it

Don't try to control it now

Love is so free if it's valid

It's not encased in a crystallized vow

Open the windows to freshen the air

Water the flowers depending on you

Breathe it in if you really care

To know yourself, to know your truth

Love isn't effort, it never was

Its intoxicants made by nature, they were

If you truly feel it, you'll have a buzz

And those minutes in time are all a blur

The freedom is truly amazingly free

Your choices in love are meant to be

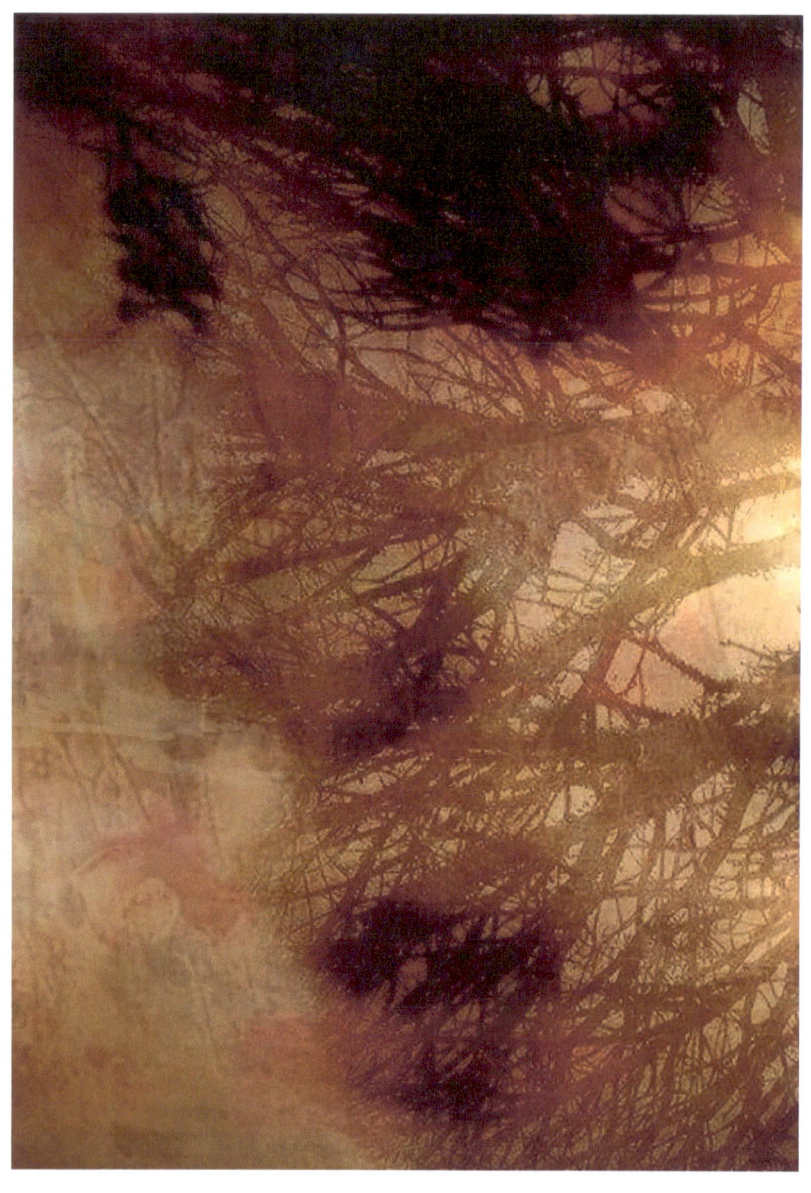

Let's talk about living, with a view

'Cause you love life and so do I

We'll love each day, just me and you

A world of kindness in our eyes

Now those who wish, may all join in

All efforts aimed at higher ground

Some may say, "Here we go again"

In circles, we have been around

Your summer days are filled with light

The energy, beaming, from your core

My autumns balance day with night

Each day being different than one before

Our higher ground, still humble, leaves

Our seasons contrast different needs

DANIEL HENKE

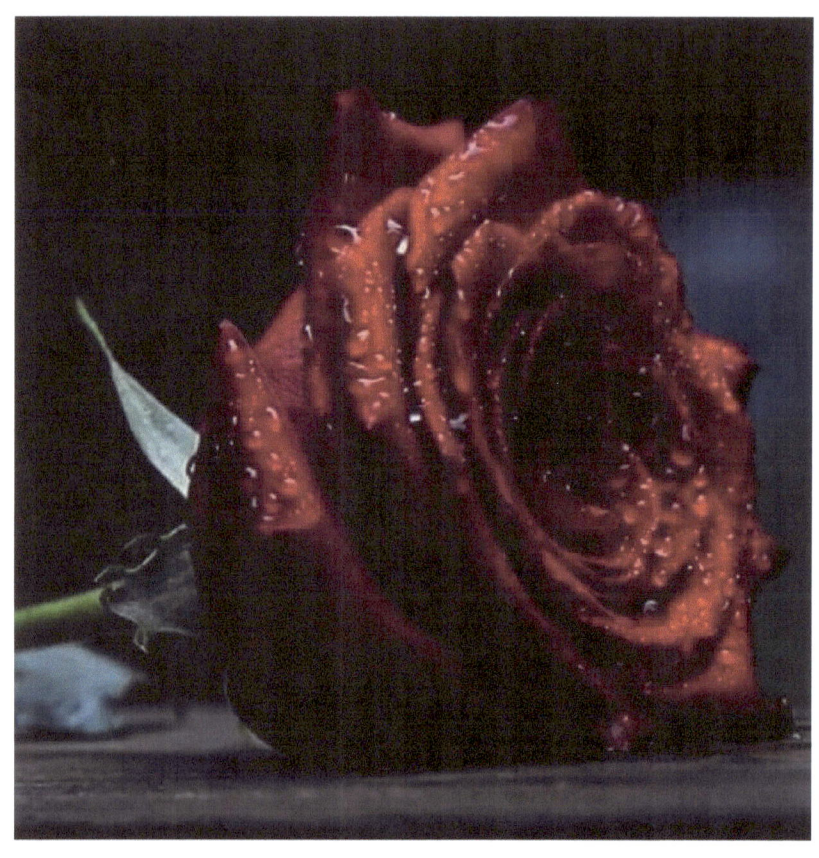

Men of few words, speak with their actions

In silent respect, their confidence calms

How deeply they love, not with their satisfaction

But thinking of others, in light of the dawn

Awakened, evolved, so far beyond brothers

Modernized women, still shedding the past

The modern man, equaled, on the plane of his lover

Tradition's, in dominance, each life is their last

We're proud that we've come, so far on this journey

But realize we still have a long way to go

The souls need to merge to avoid any fury

Man and woman, true partners, both under control

Under control, words putting it right

Our minds, truly equal, bringing Dawn a new light

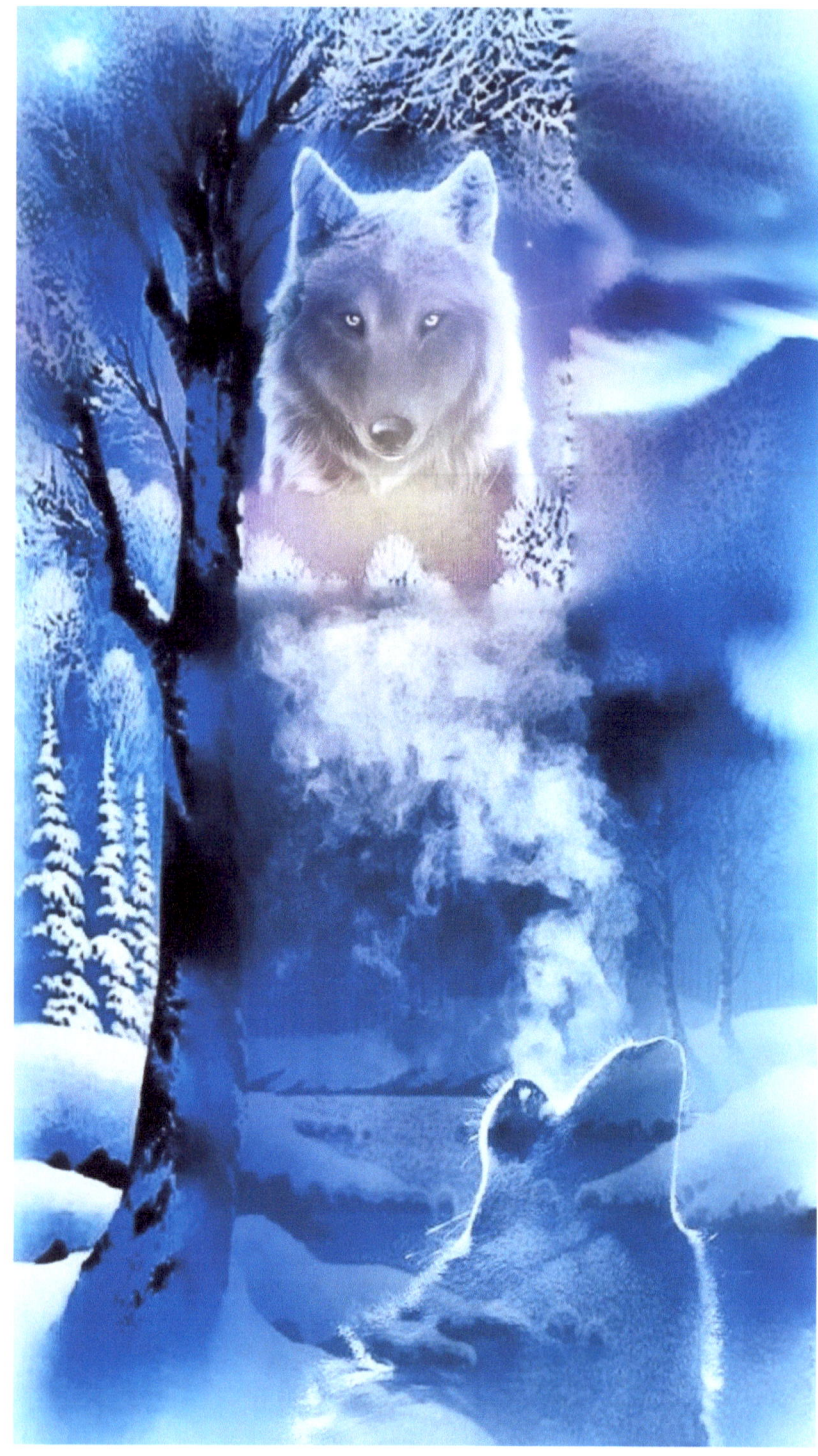

Misunderstood, even when close

The spirit of life's sound, towers

Deeply thrusting ears of its hosts

Allowing lifelines to feel the power

The power of souls beyond physical Earth

Pets the planets weak of heart

Beaming the energy that life is worth

Life, newly granted, came here to start

After starting, spirit seeks a guide

The spirit animal comes to us to tell

"Feel pride in life; and rarely hide"

The power of being, is being well

Spiritual freedom is yours to claim

While living, allow your soul, the same

DANIEL HENKE

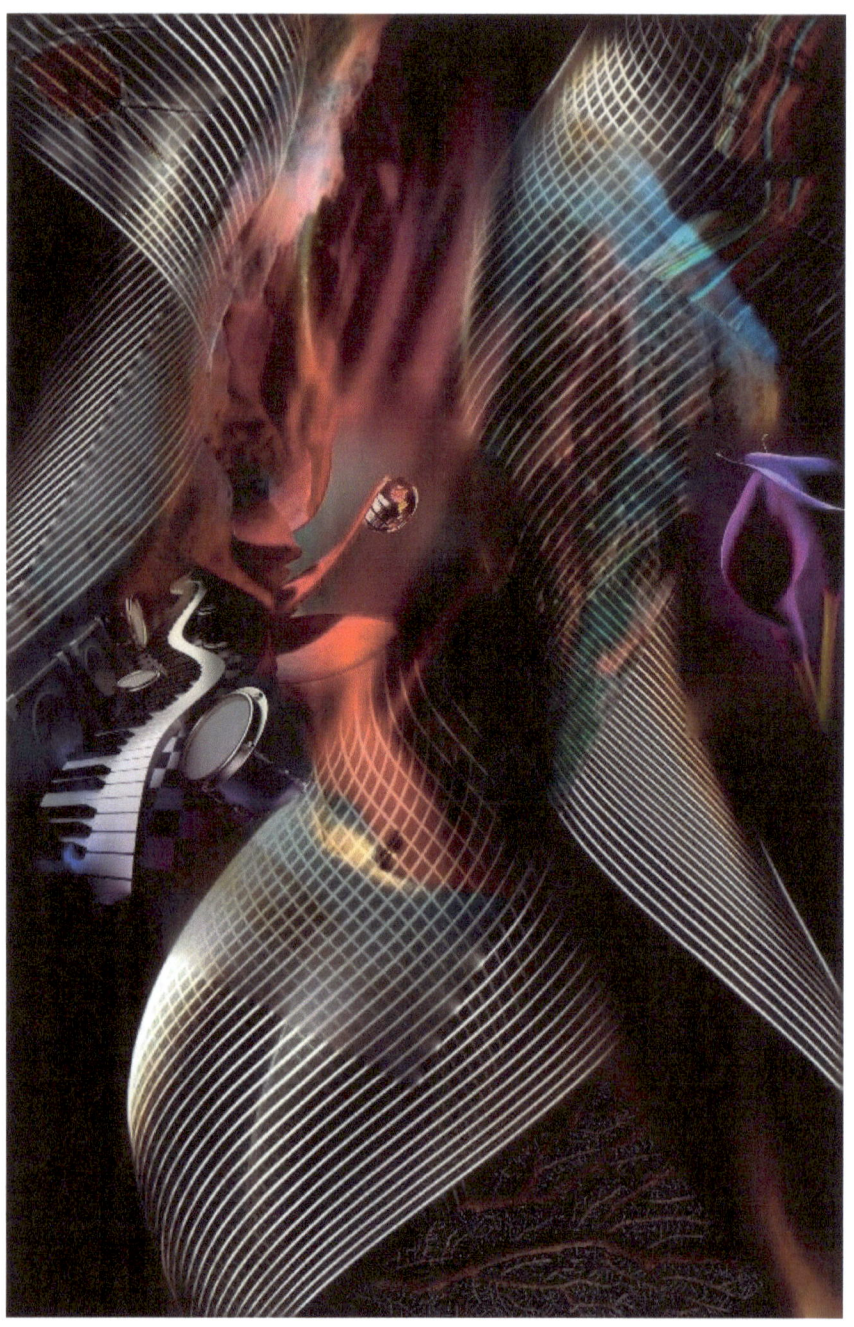

Modern times, when mixed with age
Challenge more, our sense of right
They watch us, how we turn the page
'Cause sometimes wisdom loses the fight
All the learning should have told
A story that survives the nights
But nightmares torn our bodies cold
Until the warmth of morning's light
So team us up with one who cares
And always sees the missed steps coming
Walking with us, ignoring the stares
Of any others' frequent judging
Good dreams overcome the sounds
Of better judgement falling down

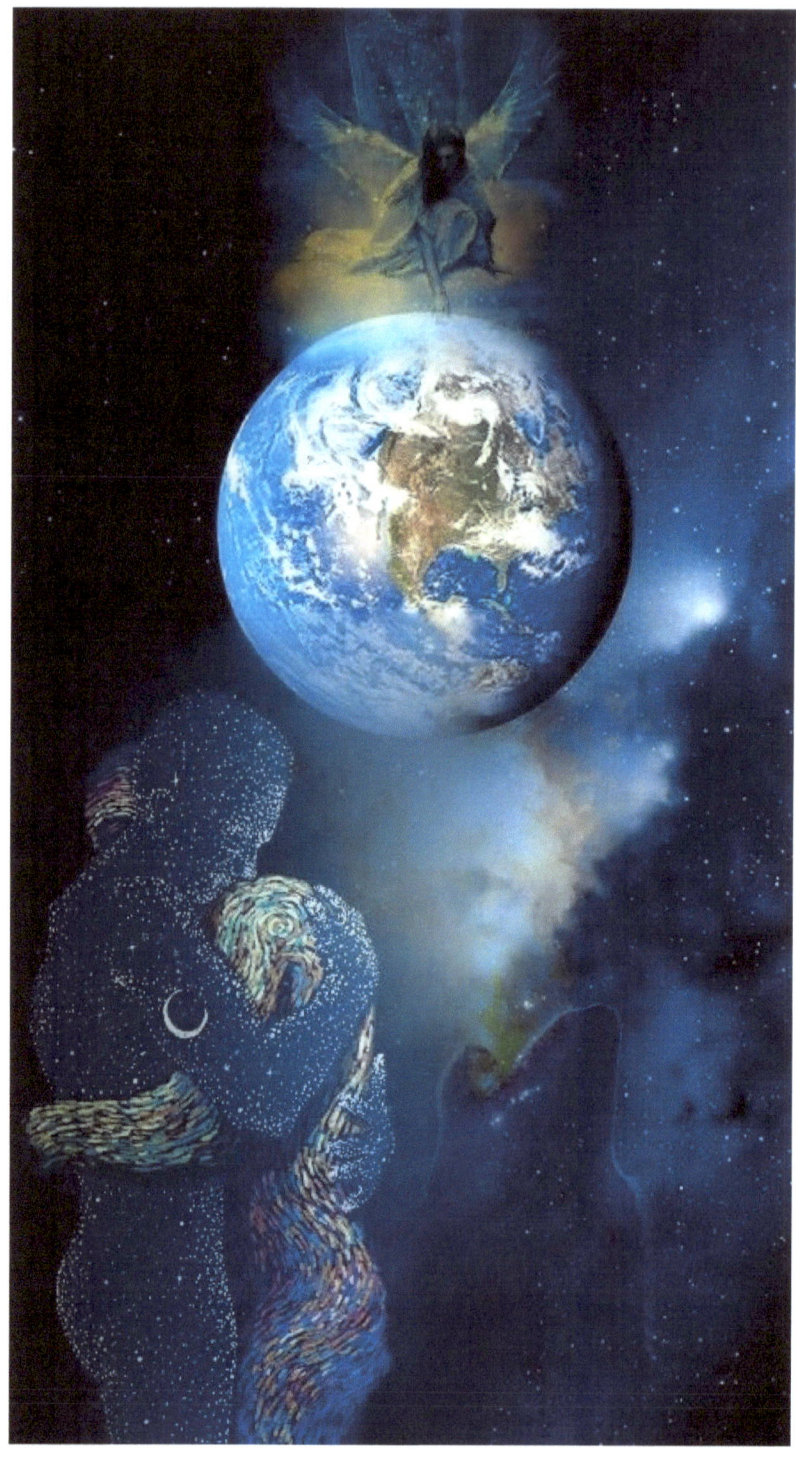

Milky ways of explaining our Earth

Fail to meet the standard of miracles

Try explaining what love is worth

To pause the open mind of an oracle

The song of a whale in the vastness of space

The whispering wind through the needles of pines

Putting words of awe in love's place

Exhausts all the alphabets; every kind

When we feel it, we run to tell others, we fell

But they can't relate 'cause it's too unique

We use our own words; each other we tell

But concede the words to our bodies to speak

Right after we loved our body's words

We talked with our souls about what we heard

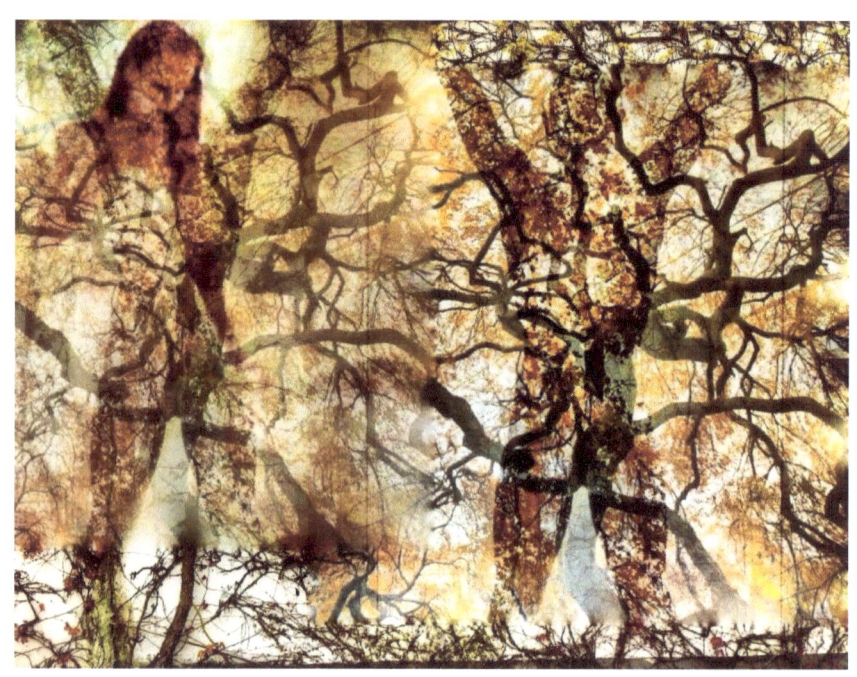

Most poets write words that few people read
But had more of them felt the meaning conveyed
Someone may have found what they need
Someone may have found ways to be saved
But what they save with and what they save for
May not matter to someone's soul
The feelings in now, weren't, ever before
For human regression collected its toll
What many are missing, in front of their nose
Is there, within their own equation
The path you want is the one you chose
The day of your birth, mapped, on occasion
Words are just language, but never die
Neither will the energy your soul satisfies

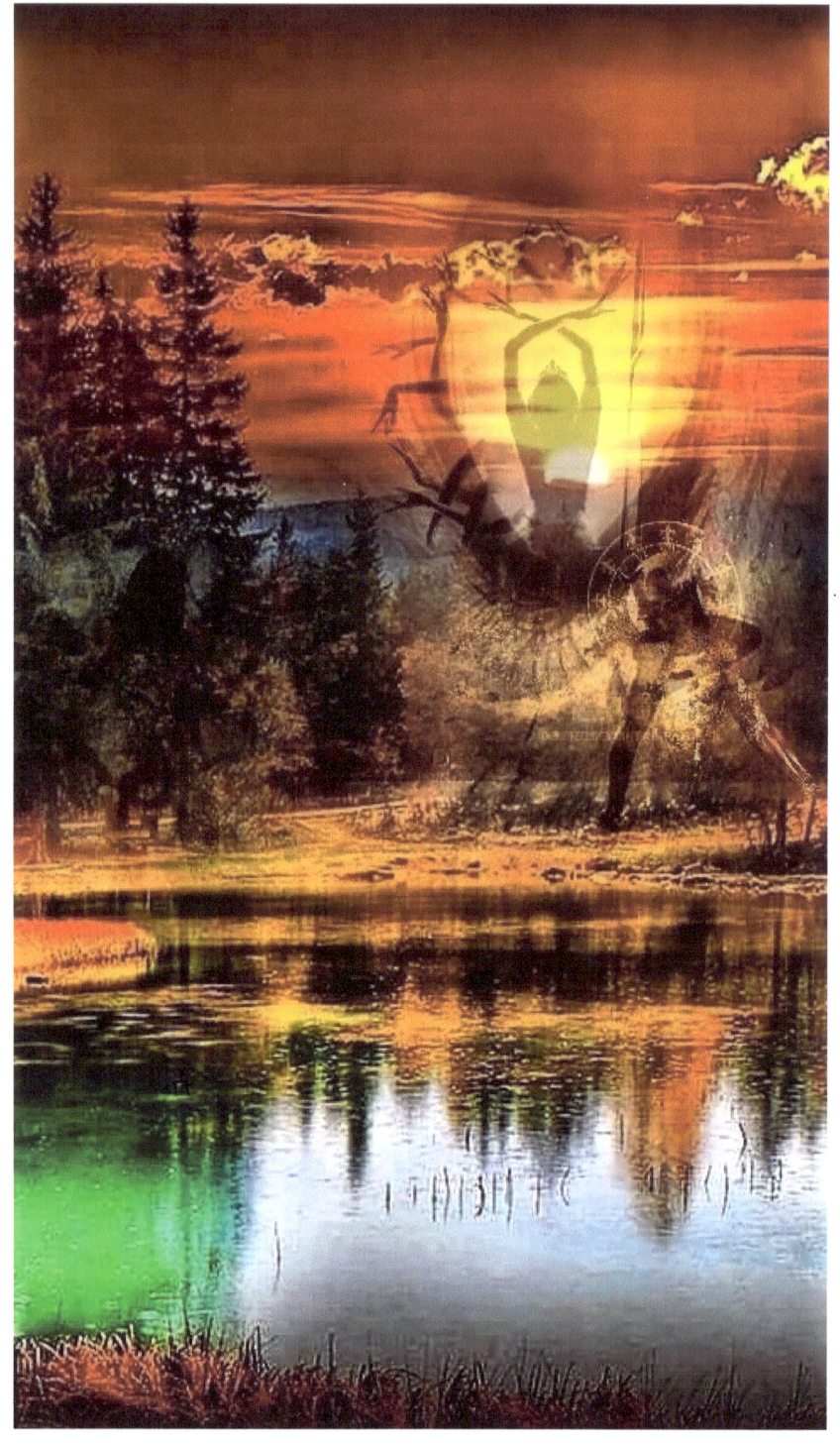

Live in fear or live in peace
The choice is always yours to make
Those scary things, they matter least
While comfort's there to celebrate
Release the tension, break the spring
There are comforts packed in every case
Open your soul and let it sing
The song of harmony in lieu of race
The trumpet is louder at battle's end
There's more of hope in better times
Life floats upon the love you send
And battles sink, when crossed, are lines
Parallel paths lead further together
Seeing passed, the seas we weather

DANIEL HENKE

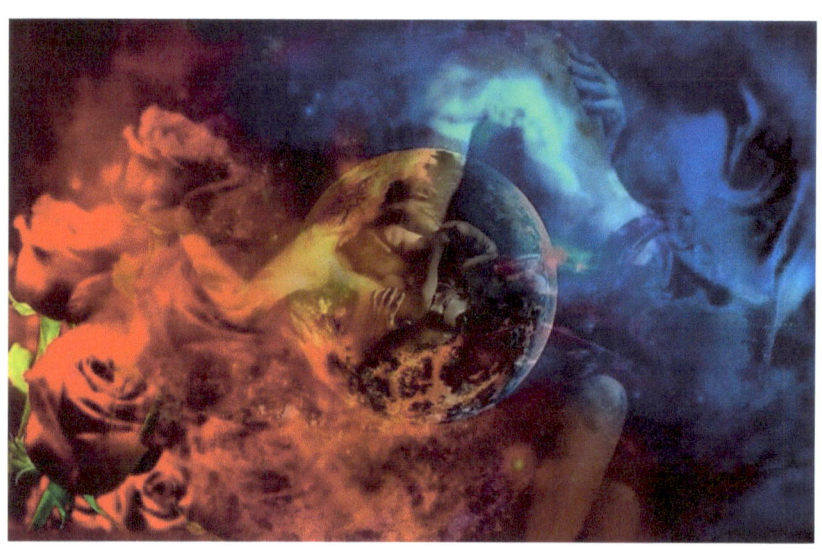

Imaginations just can't seem to see

The concept of Earth, such a large scale

The number of atoms composing one tree

The force of wind that fills all the sails

All of this beauty we take for granted

The fact it was granted, evades our eyes

Our nature is free, and humans, enchanted

Respecting the beauty, invariably wise

Then, there is you, in front of me

Granted a soul, enhancing my vision

Appreciating every part I can see

We were granted a love that was time's decision

You're more than I see, that's what I feel

We're bigger than Earth, our love is surreal

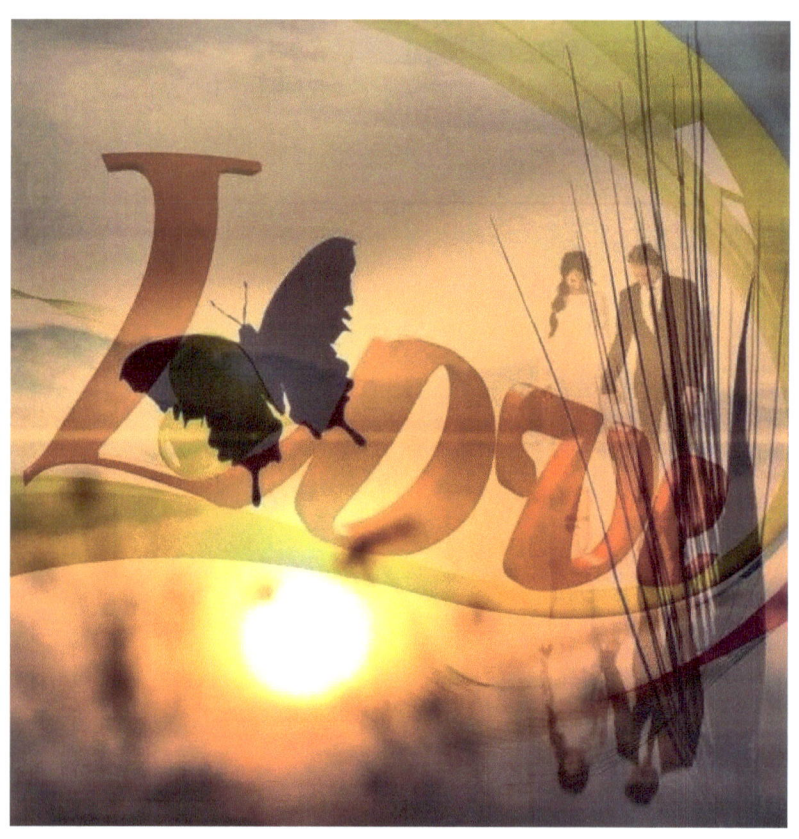

Lost or found, we find a way

Out or in, we're breathing easy

Very deep, our words in play

Every time, though barely speaking

Love in life so optimistically hoped

Or was it understated by some

Veritable mountains, perfectly sloped

Even, we find, our own way to come

Leaving is hard, that's why we don't go there

Over the part where challenge creeps in

Veering to songs, stopping to stare

Every time we border on sin

Reaching for stars, our rosy eyes blind

Several realities, intentionally undefined

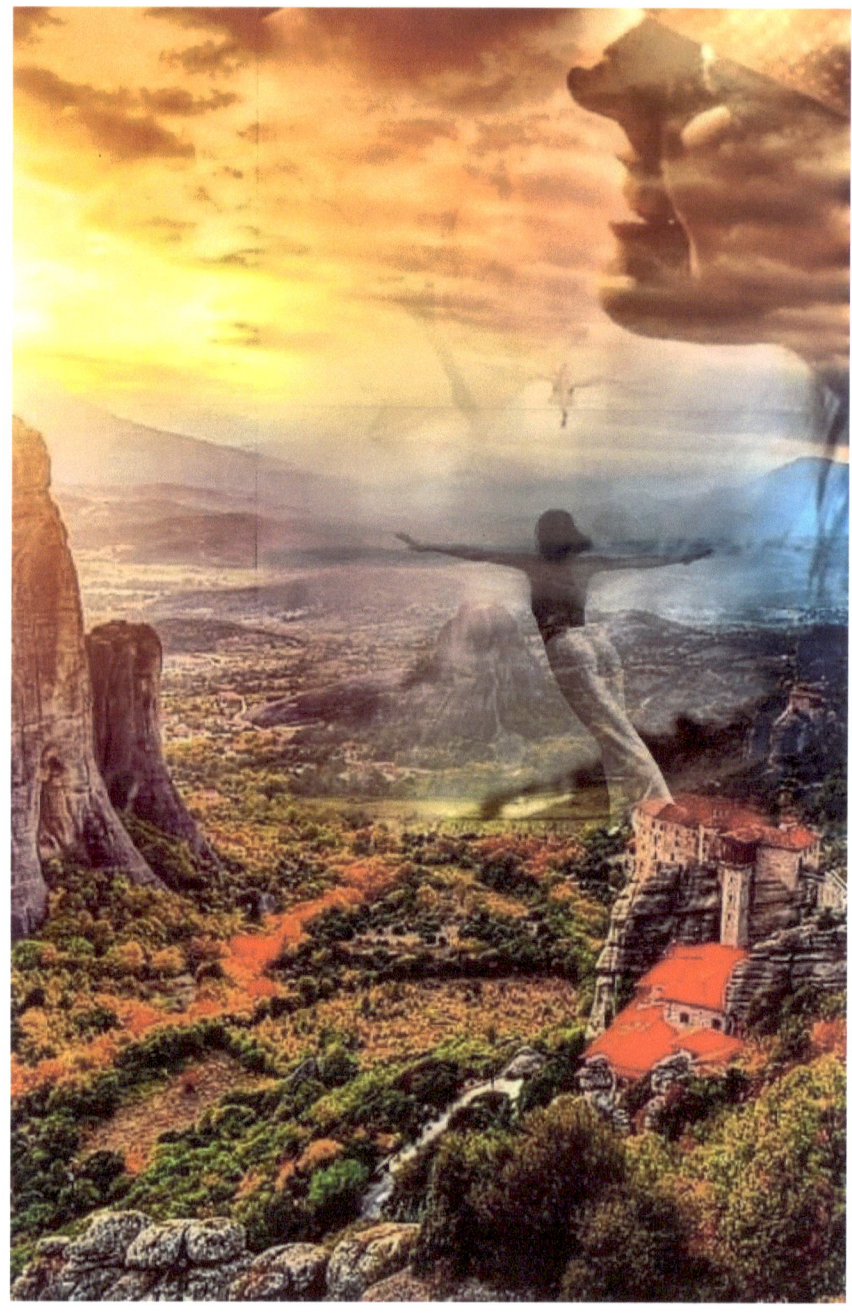

She flashed, just now, a smile that beamed
I wished I knew all her buttons and spots
When that smile lit, for an hour it seemed
No words were needed to forget my knots
If only I could give her some, thing
That held the button to smile, in
A possession that beams, maybe a ring
But, then buttons will need pushing again
I want to believe that I am a finger
That presses the button that makes her smile
But at times my vanity just won't linger
My distance from her consuming a mile
Humbleness fights with my vanity wile
My hope fights reality to win her smile

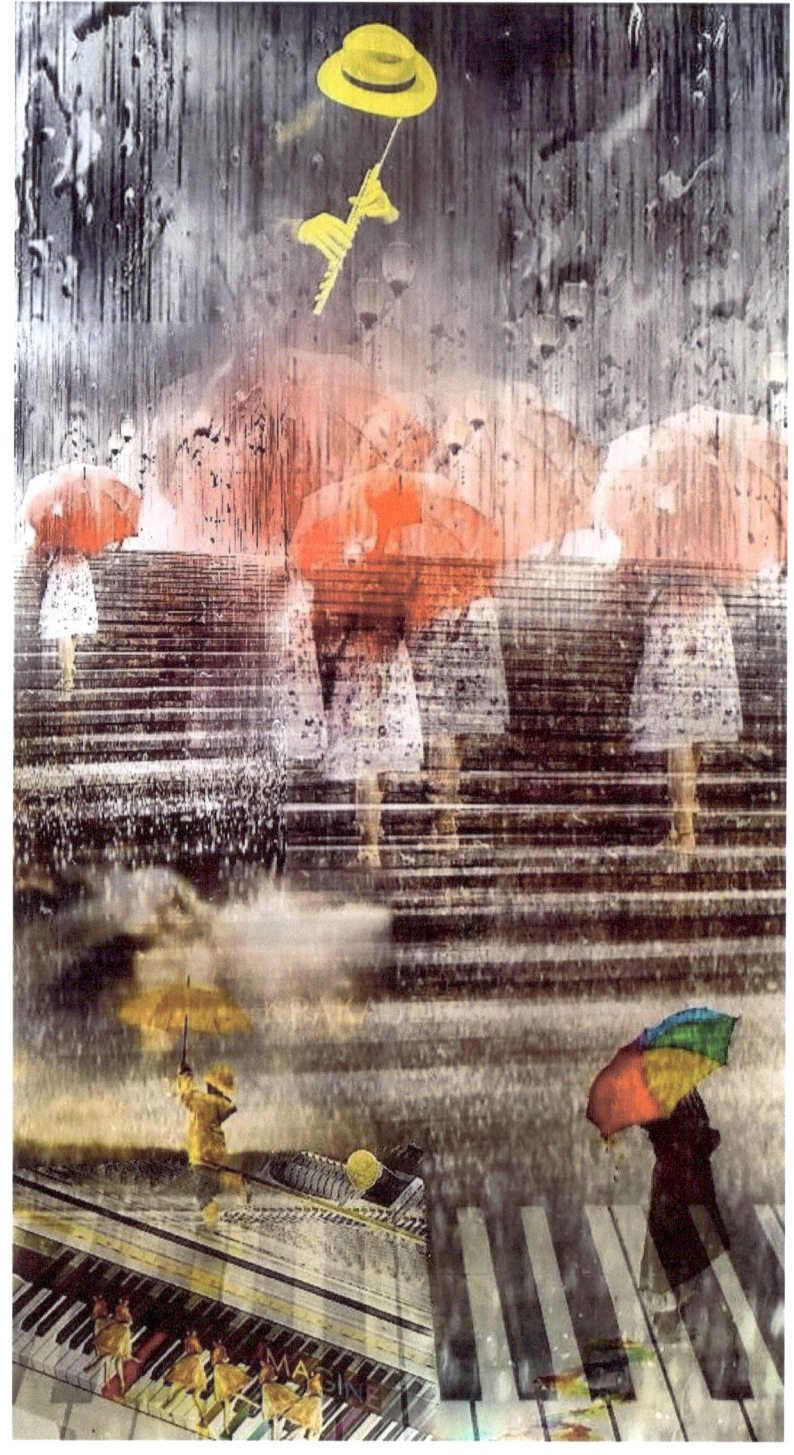

Seven virtues born with your baby

Beginnings are innocent, so they say

Seven seas sailed brings iniquities, maybe

Seven colors balance a rainbow each day

Seven chakras defined by humanity

Seven wonders of the world

Why just seven, it's insanity

Seven days each week unfurls

Champions win the best of seven

Enduring the journey without knowing why

Beethoven's seventh said to be his best session

The note is the highest in the seventh sky

We live with this number, it's lucky they say

So rest on each seventh, your own judgement day

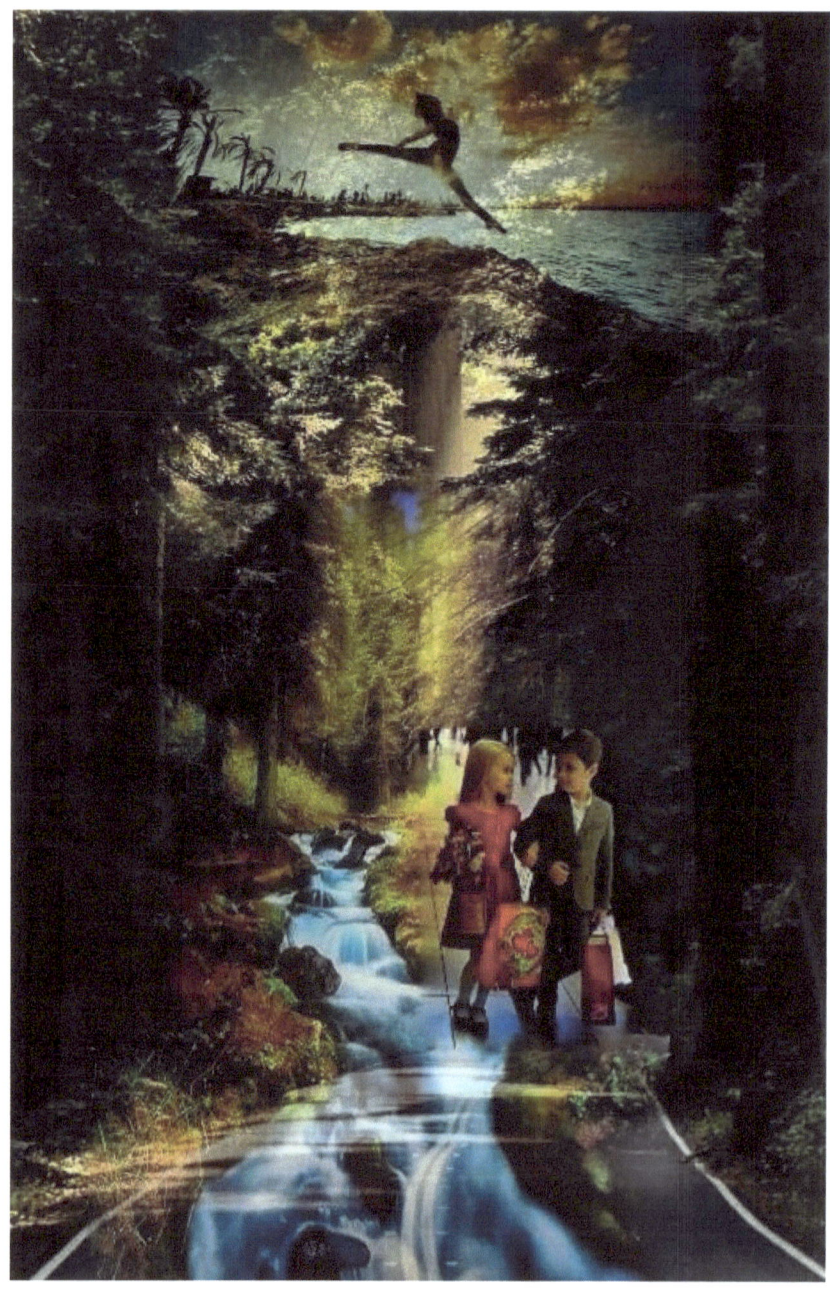

Secrecy won't serve our court

Kings and queens were meant to share

We court the world, our last resort

On the surface, we are there

In depths we need to know truth's course

Too many directions get us lost

We dive with passion, not with force

In passions' world, there's less of a cost

The truth alone can set us free

Life needs to tell us why we're here

We cared for others, but still can't see

The truths of purpose in our mirror

Balls in our courts, but how do we play?

We wish for our will to show us the way

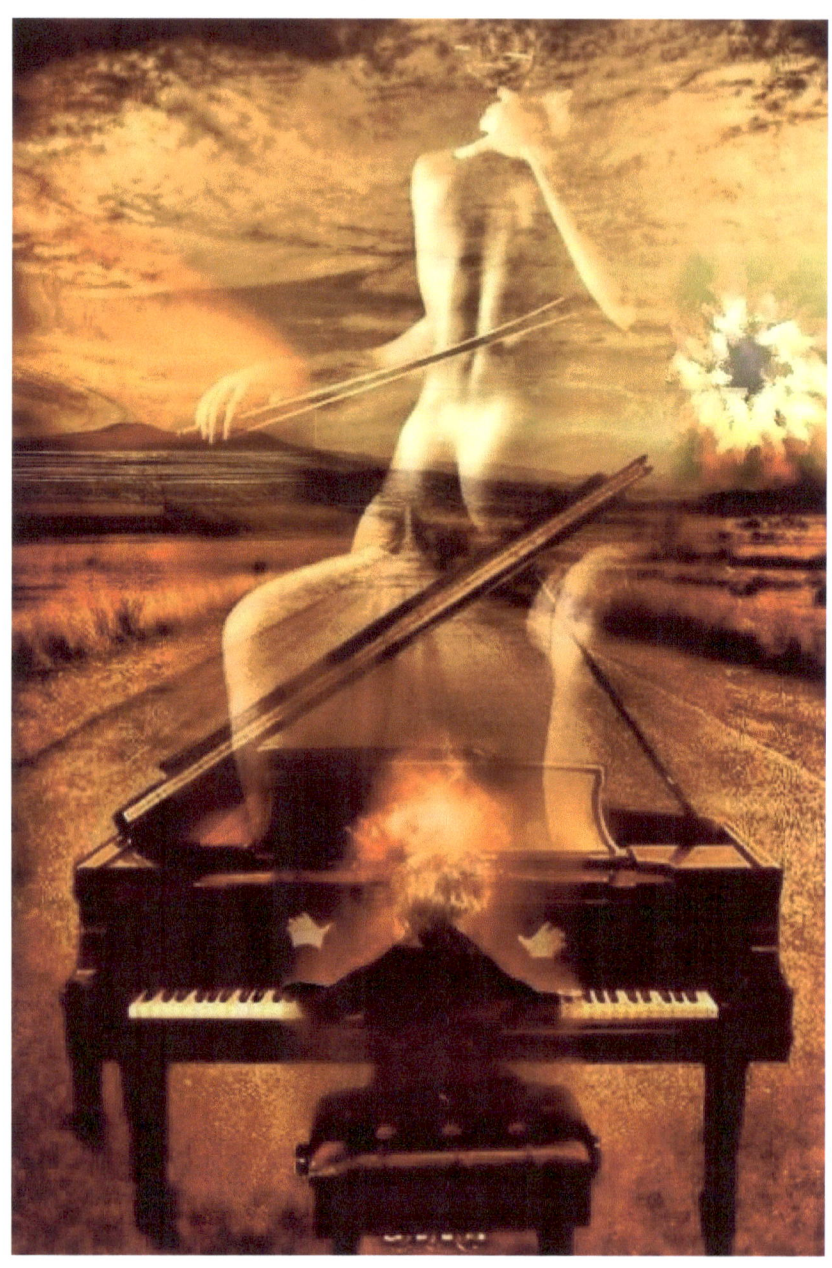

Play it hot, now, play that song

Trust is the color of the sunset's eyes

Strokes of music all were long

Length of chords that pleasure sized

See the sound that beauty makes

Wherever your vision chooses to rest

Beauty lives for goodness' sakes

'Cause goodness strives to be its best

The bottom line plays under tones

And lifts each time it thrusts its clefts

It takes, at times, it thinks it owns

More when night chooses rest less

Make your music when your party is giving

Five senses of pleasure make life worth living

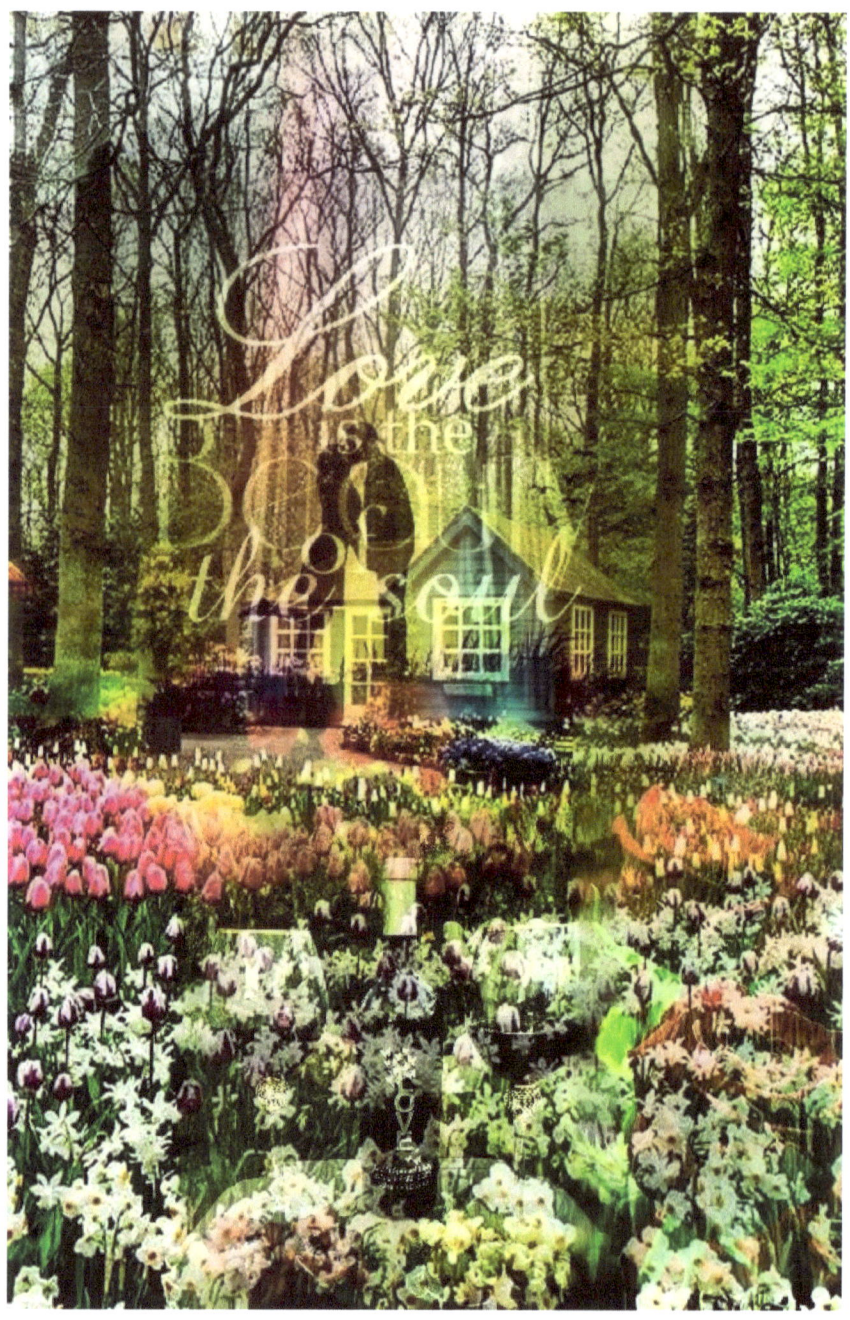

Love is a language, so it seems

Not just for two, but all those close

It raises hopes and feeds most dreams

The ones deserving? Every soul!

When choosing two to focus hearts

The chance love takes can last forever

Destiny's hand chooses how it starts

And feeds a fire; it's oh so clever

The smartest and amazing part

Is caring of each, all for the other

Caring kindly for the other's heart

Sharing life's passion with their lover

Love is the beauty in all that we know

Love is the beauty of the soul

It's okay to have more than one, favorite, color...

Transpose time, two moments you saw

Your favorite colors coming to light

Your nature never knew any law

Governing the imagination's hind sight

Why does one color cause you to feel?

Why does light produce so many?

Why are our feelings so hard to conceal?

Why do we wish, sometimes, there weren't any?

The answers to questions are only your own

Don't question those things that make you feel best

Things that you know just wouldn't be known

Unless they're answered, so right the test

The being you are is more than a dream

The colors you like are the ones you are seeing

Wonder, trust, and love are free
When missed they leave a doubt
Of really what was meant to be
In the moment, they're in or they're out
When in, your heart, is beating fine
When out, the wonder wanders
When in, they never cross the line
When out, some time is squandered
Look in your heart and keep what you will
See the love that's sent to you
Those who love you always will
Especially when they love what's true
The only sun I see each day
Is the light of truth that's sent my way

Think of the person inventing the harp

Born from one string, created a tone

Wanting more music, and very smart

Gifting the music the world would then own

The harp's first strokes, maybe amusing

Like a baby, learning by sound and by touch

Our minds have a way, of sometimes confusing

But reach a brilliant conclusion as such

Each of us is an inventor you see

Creativity grows in our minds

Your future's certain reality

Is something more that the harp wants to find

Fate has a master plan though

Your harp is destined to become a piano

Who is she, the wolf that howls?
Assumed by some to be a male
Appearances, seen past by owls
Divine feminine air, in spirited sails
The sails on boats in setting seas
Deep in culture, floating in now
Self-empowerment meant to be
Spiritual paths showing her how
You see the wolf in elegance
Perspectives only you can choose
The female earning reverence
As nature's procreation spews
Misunderstood, the wolf, its life
It's power, so mystical, it conquers strife

The sunsets tell you you're never alone
But who's voice is it that you hear?
The sunrise sings in spiritual tones
Cosmic forces that quell your tears
But what is really the reason we cry?
Seeking some others to touch our heart
We contain emotion, at least we try
But tears unite, they play their part
The voice we hear is in our head
It's sound enchants and now you know
It's the tone you hear, not what it said
That makes you understand it so
It's the voices of lovers and best of friends
That reach out in choirs again and again

Sakayume

Nature's bastion builds the streams
Of spirit's action showing hope
Bless your world with angel's dreams
Peace, the spiritual isotopes
Blend the colors how you like
Your mind empowered in now
Bending darks that move to strike
Freedom's desires for showing you how
Now your world is showing promise
Transformation set to come
Keep it true by staying honest
The inner children asked for some
Showing kindness proves to be
Ultimate selves, spiritually free

The angel's valley sings its song
A song of nature where visions gather
Freedom has been here all along
A natural miracle of life that matters
Come if you like, you're always invited
Find your peace, it's not in question
You're guaranteed to become excited
In beautiful meadows, the angel's bastion
Imagine this place within your heart
Always aligned with best of intentions
If you listen closely the wind will start
To tell the secret of spirits' invention
Love lives here and welcomes all
The stars repeat it as soon as night falls

The face of your music changes
When you flip the page of your book
The song you sing rearranges
When you finger the keys the changes took
Your shadow moved and took its note
You're moving differently as time moves forward
Looking for a sequence of antidotes
To avoid the ills you wish to ignore
Advice to the young at heart
Make believe whenever you can
Live your fantasy right from the start
Sing music equally to women and men
Love is a promise, make it live
You have so much of yourself to give

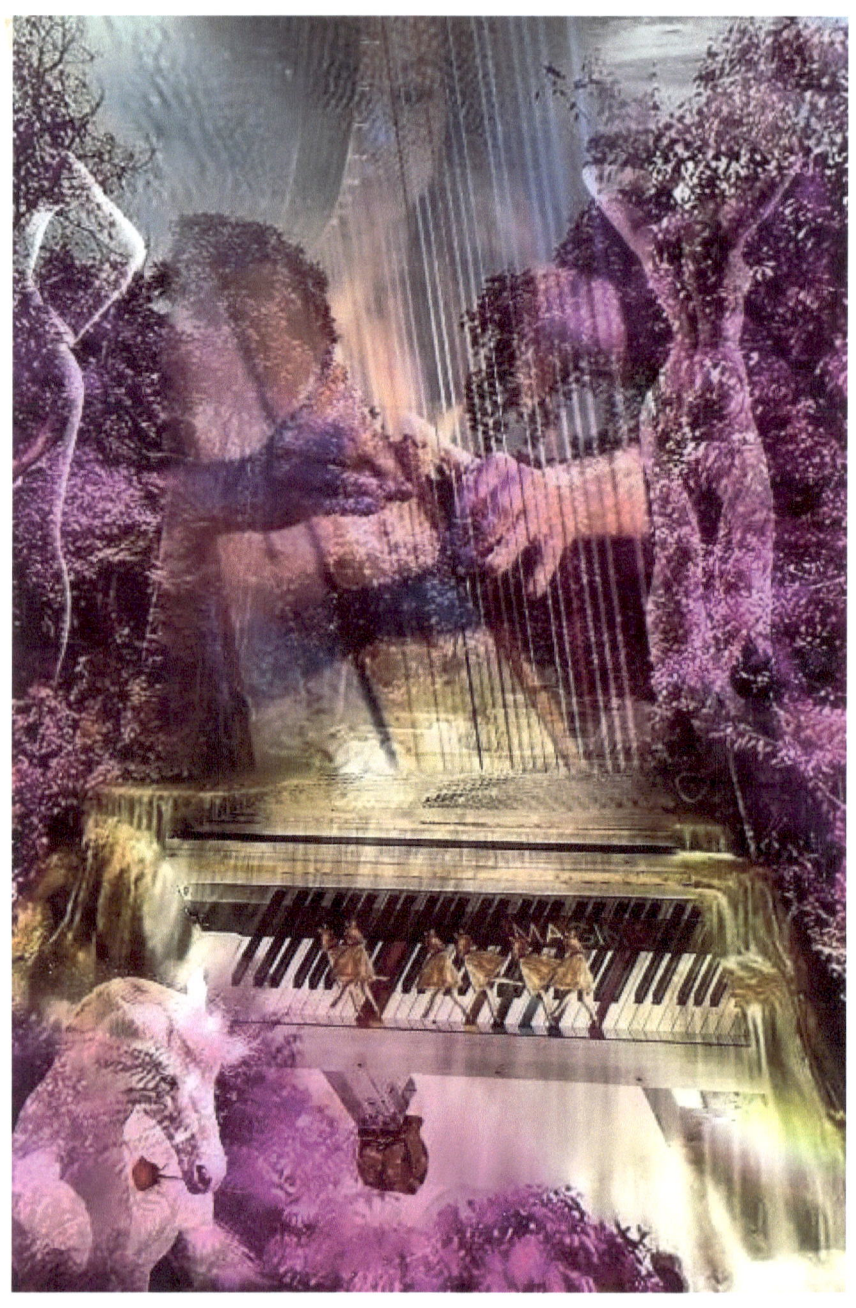

The music I write may seem like a poem

But in it, you will always hear

Rhythm, the sounds that I call home

The art or words, makes the music clear

They're positive, these words of mine

So unlike, so many songs

The paths of minds, are paths I find

The good emotions, are all, that belong

Why write the sadness and dwell in the downs

Your eyes are living to see the light

The paint on faces of human clowns

Masking the sorrow of human plight

Please celebrate your life today

With gratitude, my songs wish to play

Our paths, now one, and near the middle

Adapted our states of mind and tone

Careful we are, of not feeling little

Big love, billowing, not only alone

Moments in time, search for fusion

Of thoughts that always matter and share

Avoiding most of life's illusions

Practically knowing we'll always care

Our wish, that every moment was harmony

But cannot feel occasionally silent

Seconds coax us, oh so charmingly

Embracing our spirits, abandoning science

Adjustments we make while living a dream

Refusing to waken while drawing our scheme

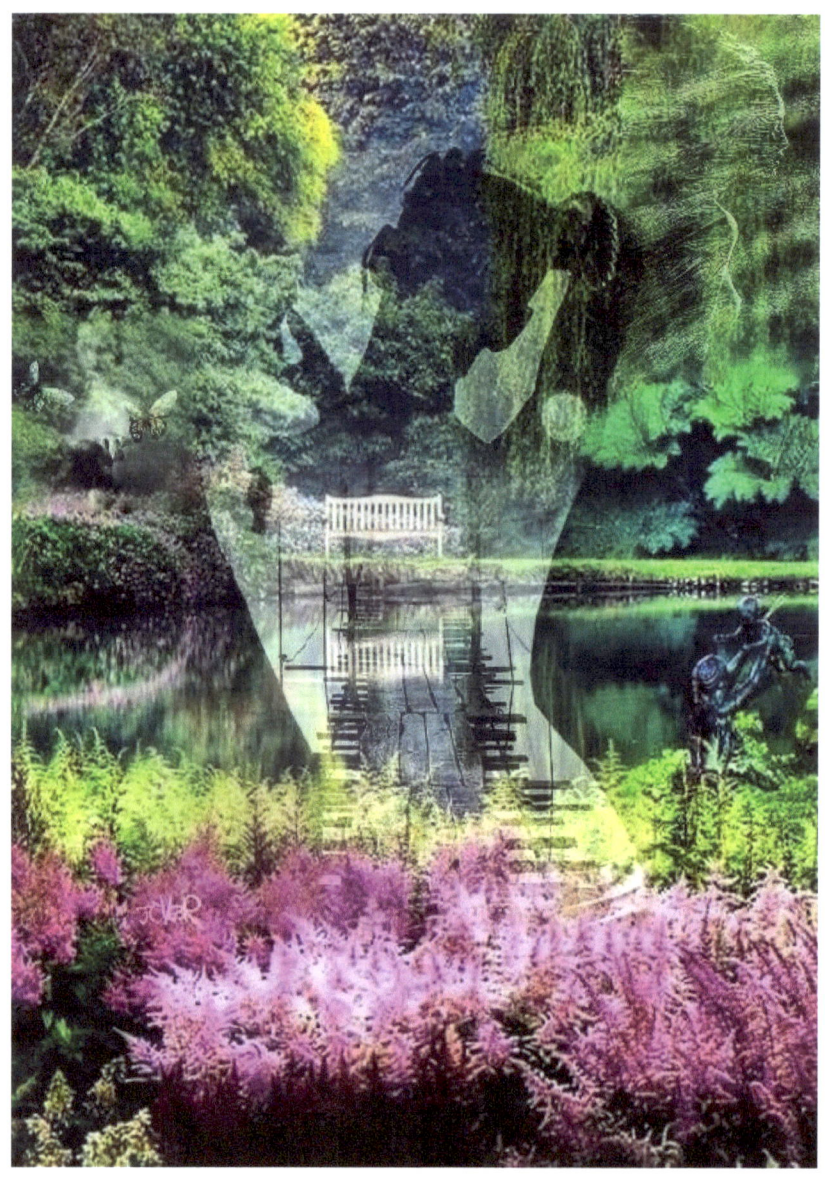

I wish the daylight showed the way
I wish for peace and love unfurled
I wish for pleasure, coming, to play
I wish for that, you are my world
I hope each second comes again
To find you in my time and place
I hope each time I'm seeing when
You offer further to be in my space
Why do I wish for what's already been?
Is what I have now feared to lose?
This movie's good, why have it end?
A Paradise Ranch is the title I'll choose
In times I think we have it tough
I offer thanks, I'm blessed enough

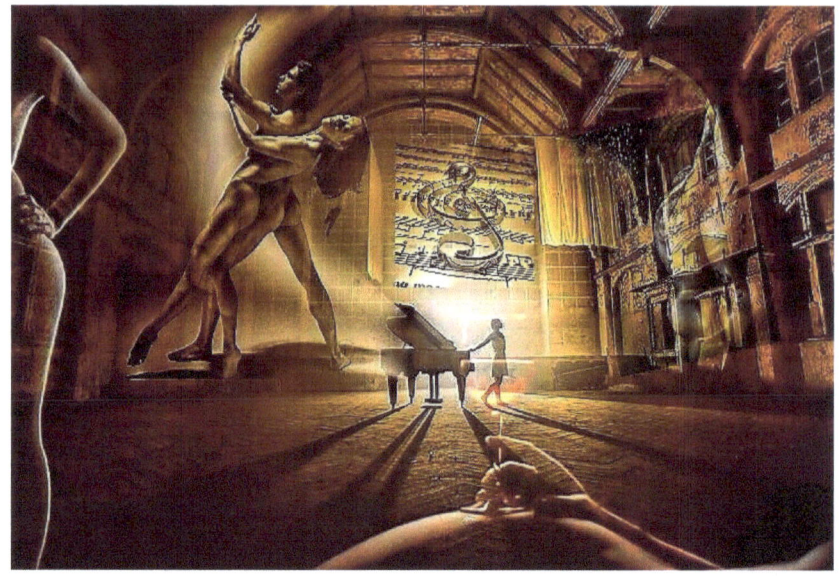

Music took a breath for me
That breath lasted a lifetime
Allowing me to sing on key
And flowed all through my lifeline
Dancing through the universe
Free in naked times to be
Not coming last, not coming first
With ears that hear and eyes that see
Watching people look for answers
Blindly deafen nature's calls
Pain invoked by burdens' cancers
Unless they find their waterfalls
Melodies found in nature's fountains
Harmonize life in colors of mountains

My teens were not what men would have
I loved and respected all the girls
Now older, I still see the halve
Of marriage to my lonely world
My wish for men, for best intentions
To look beyond the animal drive
Of conquests that rarely deserve redemption
That if erased, my world would thrive
A lack of control is what I feel
To make it better for the now
Stories of past, all do reveal
Better ways, to show them how
Few things will change and that is sad
I wish for bettering lives that went bad

Carriages hold our souls in beds of romance...

The day on which life was granted to me
Greeted me wondering, what can I learn?
While thinking, my carriage, parked under a tree
For what do I wish, for what do I yearn
The answer would come, but I didn't know when
I needed a soul-mate to walk with in love
I wondered, where was she, now and again
This angel who's due and was sent from above
It took many years, then one magic day
I found myself in a carriage again
This time, horse-drawn, I knew what to say
No longer leading, no, where, now when
The carriage is magic and allows me to be
Content, with my baby, parked under that tree

Moments in life are meant to teach
All beings, students of this game
Playing means practicing what you preach
So preach with words that do not blame
Blaming yourself with wrong isn't right
You preached good words, so it's okay
The game you're playing doesn't fight
All doubts that came to mind today
When saddest, take the path that leads
To fields where loved ones came to play
Their game was one that served your needs
Be grateful they walked your path your way
All games end, but new ones start
Just keep those you love within your heart

Nudity smiles because it's the truth
Uncovered and always meant to be seen
Some people don't like it but others do
And then there are those somewhere in between
The smile is comfort, the look is you
The confidence should be very strong
It's who you are, it's what is true
It's what time meant for you all along
Like it now, the way it is
If you don't, it's karma's answer
For all your choices always give
The questions, all that now you ask here
Don't worry how you see yourself
The truth accepts you now, not any time else

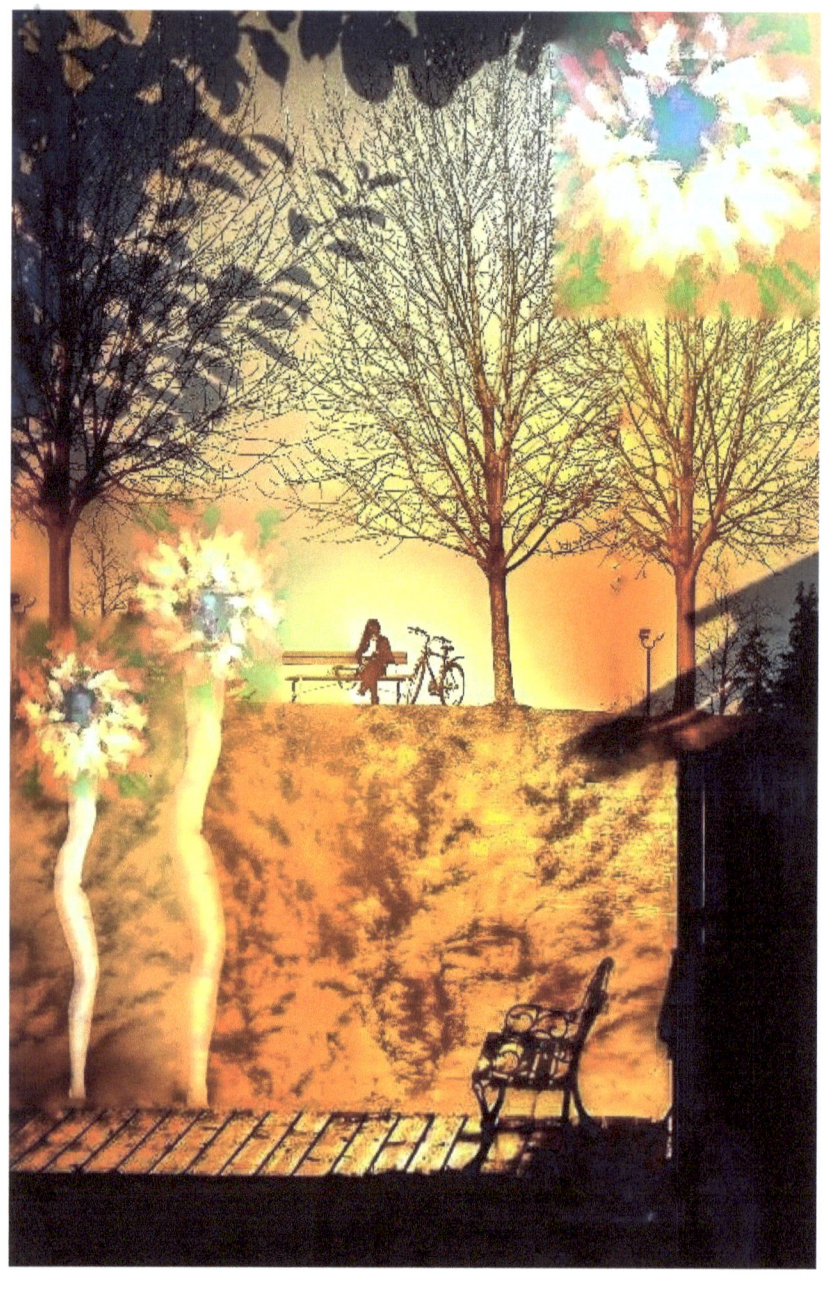

Sunbursts flower across life's scenes

Reflecting on love and it's many hues

Shades of grey seeming rather obscene

But when colored seem to introduce blues

Whatever color your reflection shows

Is altered by the karma of time

For giving, ones' self, speaks up and knows

The places where to draw the lines

We wonder who watches the lines we draw

But fail to see why they wouldn't stay

We hold our best ideas in awe

Of how we came to be this way

When feeling alone, know that you're not

You'll never remember what time forgot

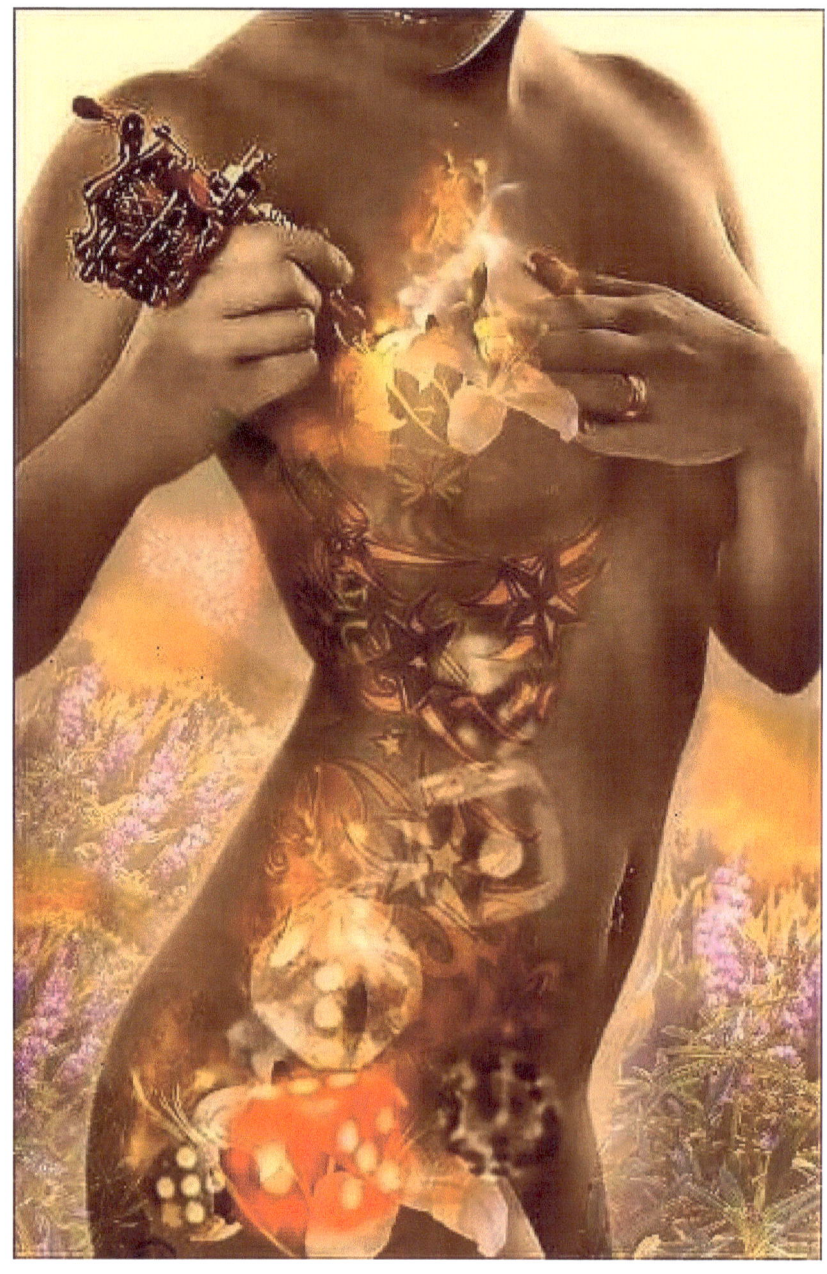

You painted flowers and shared your skin

Tending my blues with yellow shades

Greens' result, well-natured within

The sun that warmed the love we made

Our conversations wish what they say

Just natural and mutual-feeling

It's crazy how emotions lay

In random cards that life is dealing

The deck is stacked, but who will win?

Is life a game, controlled at all?

Let's paint the truth, avoid the sins

Let karma's opus come to call

Colored pasts bring their light to the now

Let's taint them with future, the ways we've learned how

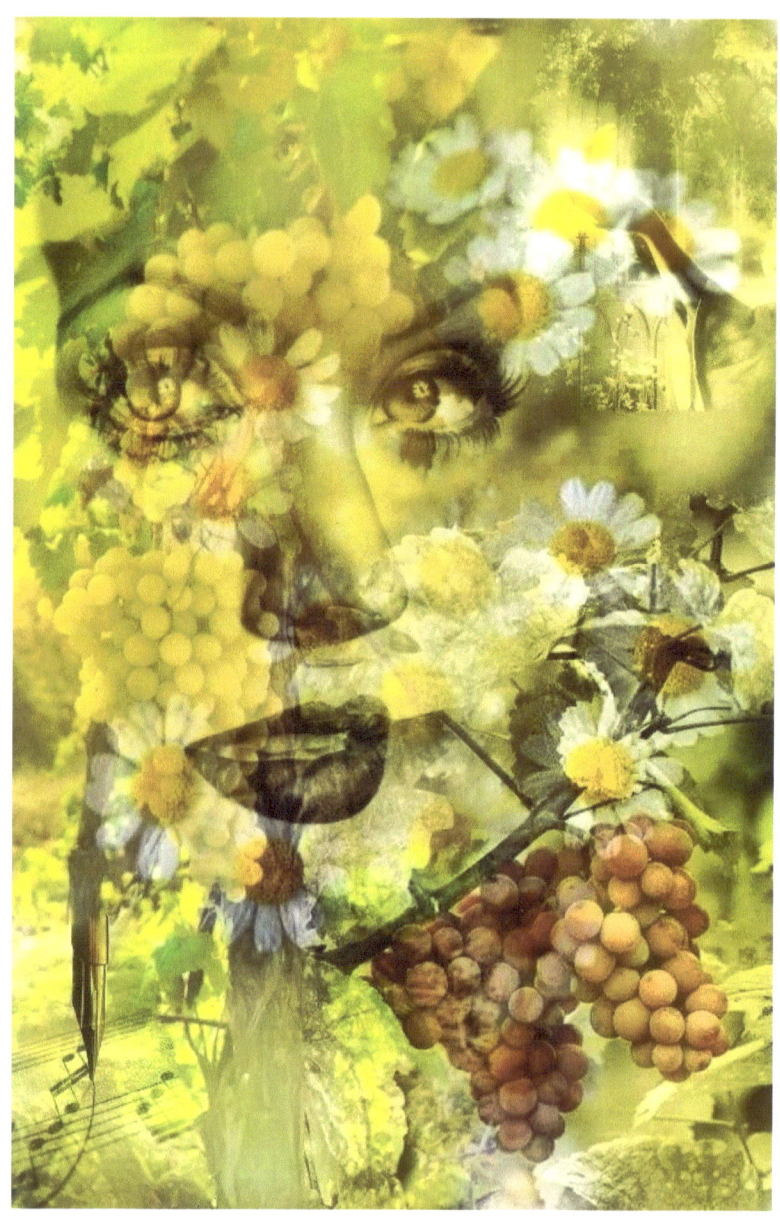

Sun day sun reminded me

Of light I take for granted

Nature really showing to be

A dream that's greatly enchanted

Monday's moon began that night

A light within the darkness now

Reflecting sun that it feels like

Resting like it's knowing how

Sleep at night and wake to sun

Repeat the one enjoyable task

To be the source, to be the one

That others feel that they can ask

The warmth of your sun you soaked in spirit

Gave wisdom for dreams and answers; you hear it?

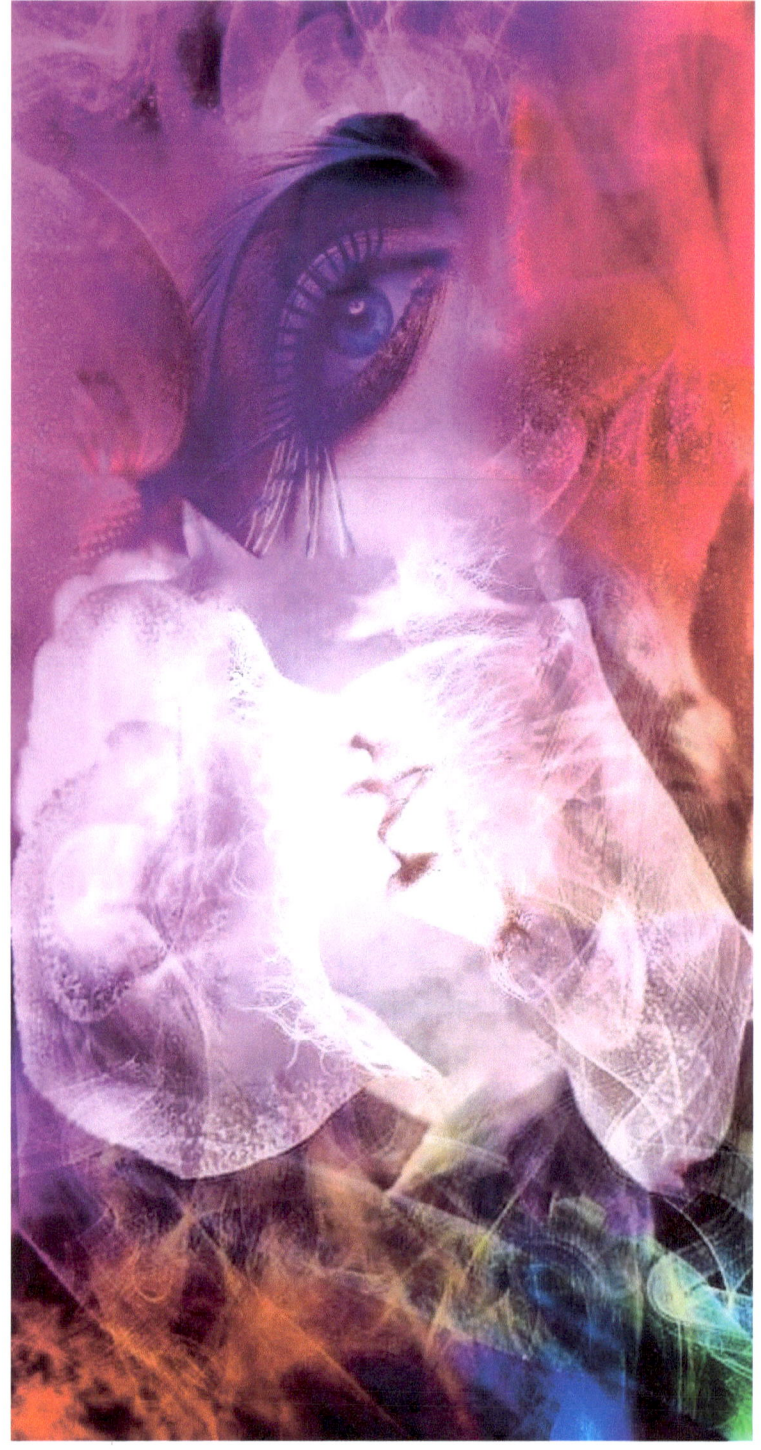

Perfect little places in space

Fit in the palm of our hands

Perfectly wet and filled with grace

Only bodies, together, can understand

Waking eyes remember the passion

Of what created the smells and the touch

Not stripped of love, but stripped of fashion

Wearing each other, feeling so much

Passionate moments don't hide, they seek

Treasure the times when the glow is read

The book of life climaxed at peak

Then slept upon a dirty bed

Those perfect little spaces in time

Are awakened when putting yours in mine

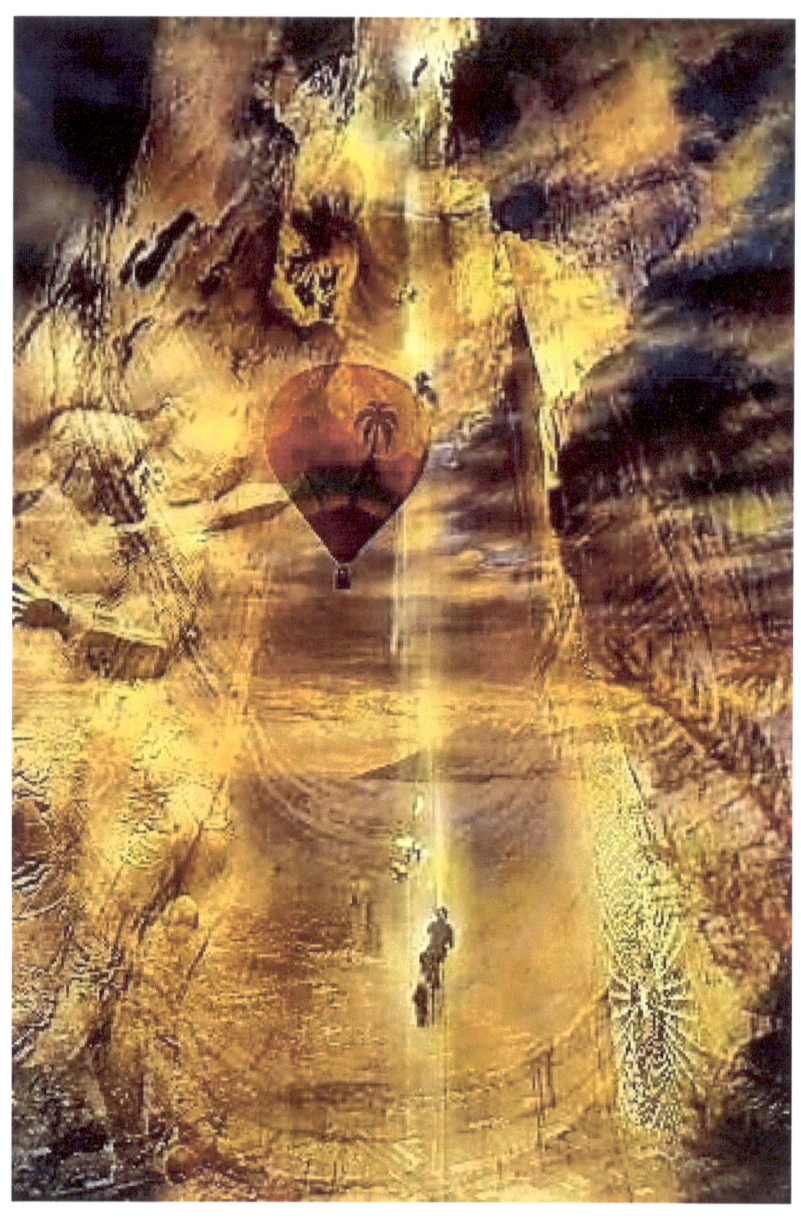

The magic of time averts the square
Serendipity makes life round
Forget the why, let life be where
All chance has lost, fate then has found
The stars aligned when gravity was fed
The chances took a path, the same
We came in places we were led
And proved this life is not a game
What are the odds of romances bud?
Blooming your flower so I can see
Setting the fire in our blood
Of love, the one that's meant to be
The magic of time is what we found
When we fell in love and fooled around

DANIEL HENKE

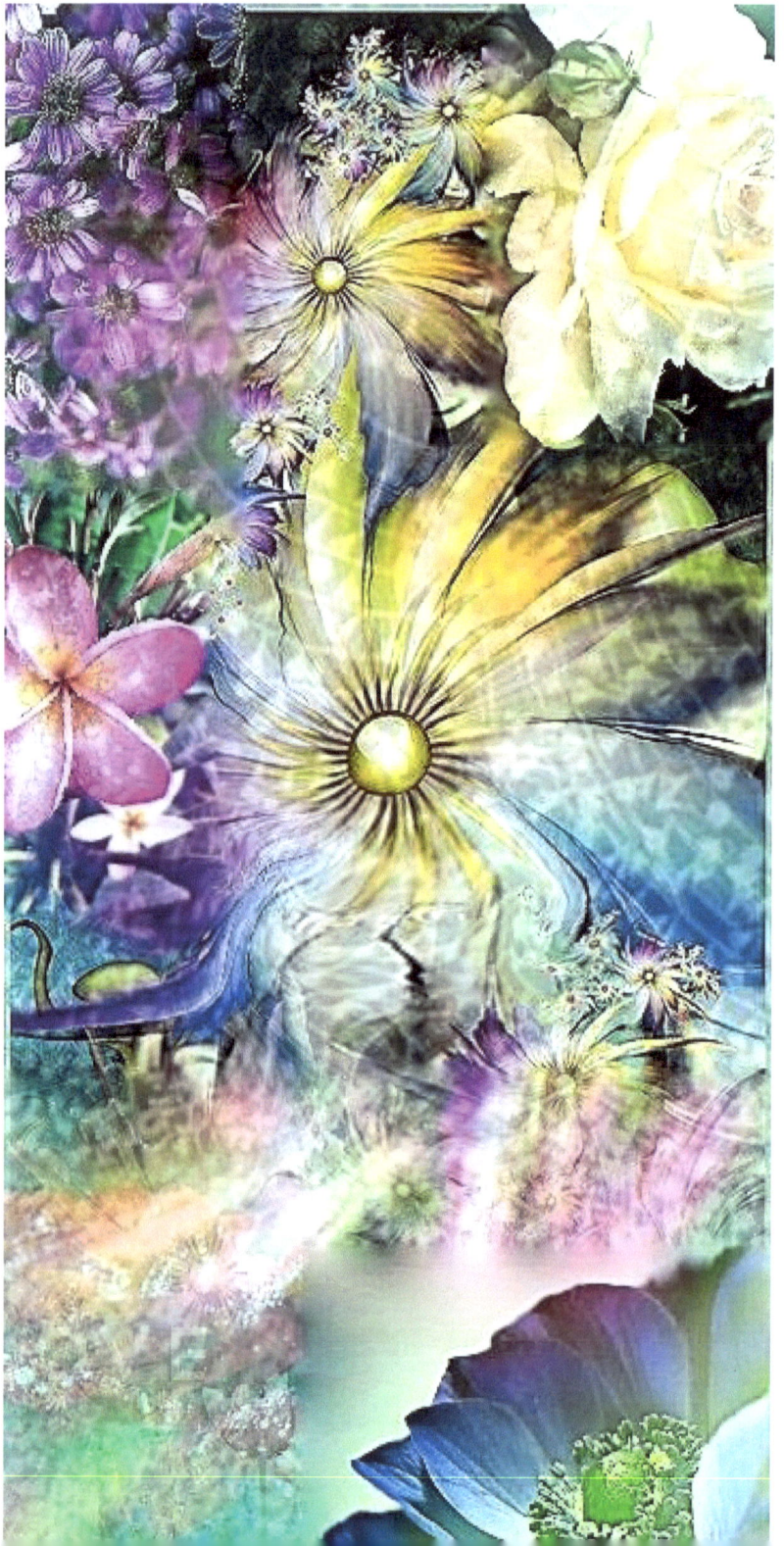

I haven't seen my usual flowers

My vision is dancing somewhere else

I used to stare, to pass some hours

Grooming, caring for their health

One of those flowers cared the same for me

And granted smiles in admiration

Angelic powers kept us all free

Proximity fueling our colored elation

The one, the flower that's singled out

When feeling free, makes me smile

Alone in time, my flowers pout

The gardener moved, it's been a while

We move our gardens now and again

New flowers will come, more smiles, then

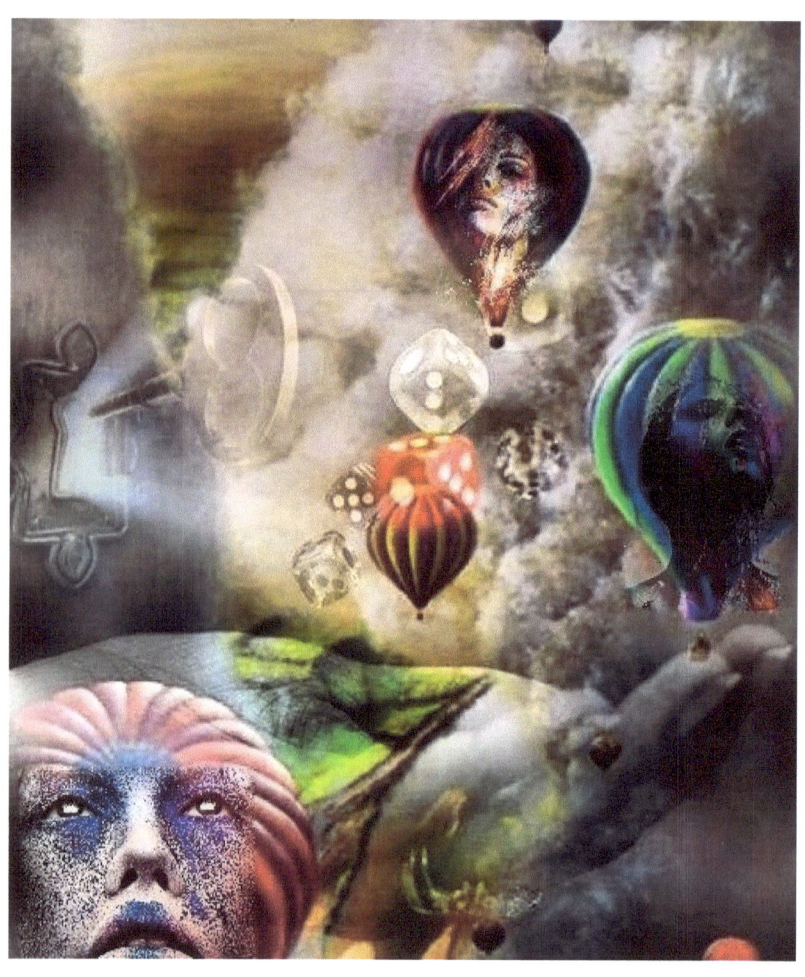

Tossing and turning, the numbers are falling
Counting on sometimes, hoping two become one
Bodies are asking for truth as they're calling
For always, to please, the stars, like the sun
Writing these riddles, equations of words
Sums up my conscience, they make sense to me
Wishing, you like them, hoping, you heard
Your mind finding answers, comfortably
Random ideas are epiphanies of how
The whens and whys were just the facts
But equations are showing you, randomly, now
Who for you care, and what quantity lacks
Tossing these words may have left some confused
But the hope was that randomness left you, some truths

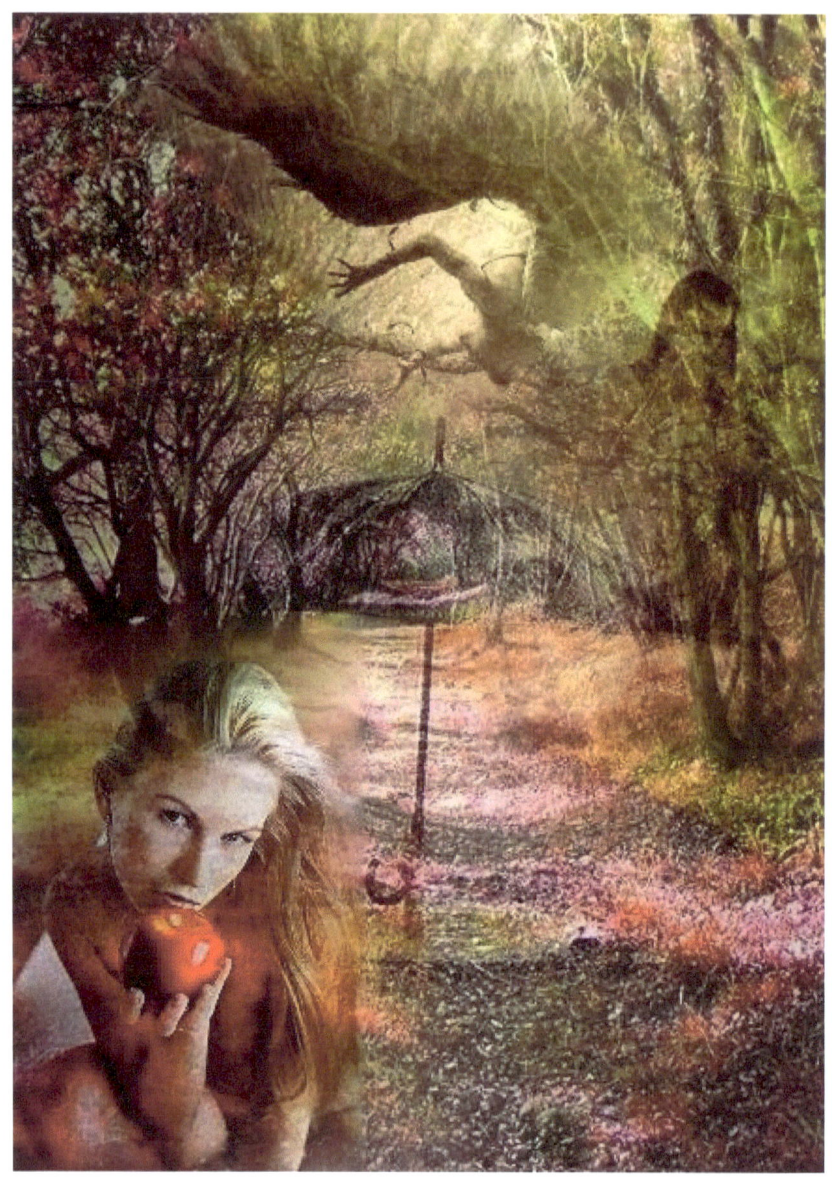

The winds of change blow suddenly

Fast and furious blowing time

Centuries of passing centuries

Colors blending lines of lines

In the end, a new beginning

Learning after afterbirth

Contests nature's always winning

On this tiny planet, Earth

Plan to live life, the afterlife

Tune into the spirit's hues

See the tones of blacks and whites

Avoid the downward tone of blues

For winds of change, you can't prepare

For the spaces of time are now in theirs

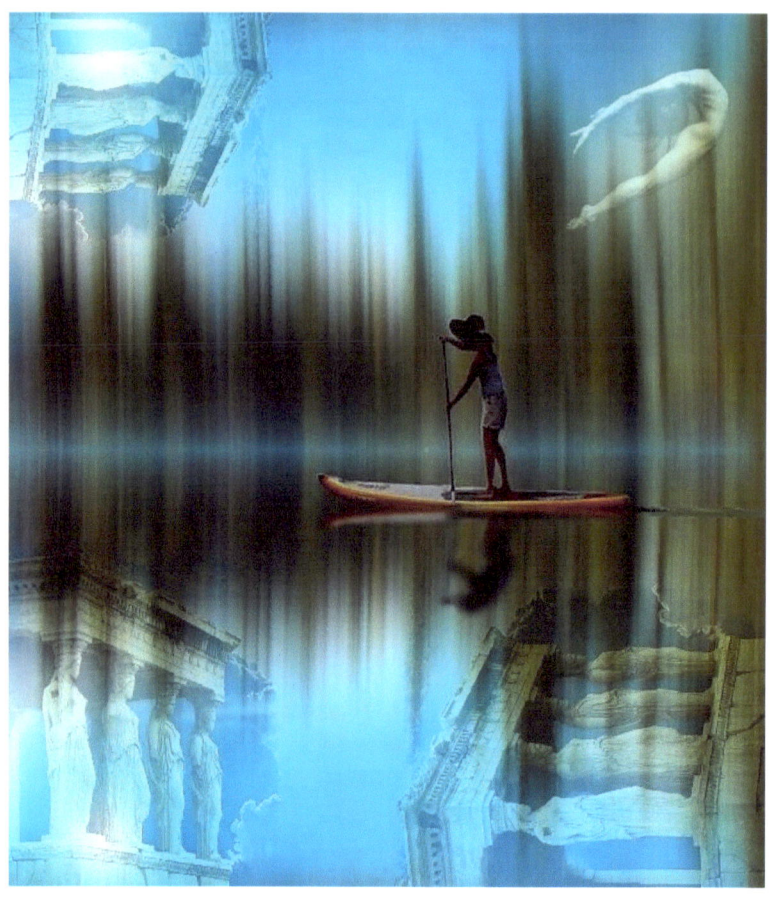

Transition brings solitude, almost every time. But as long as your friends are somewhere in this world, they can help navigate...

Where is home, and what is change?

I said I'd change the world today

I saw the chances, just, the same

I realized it changes in every way

When I was kind last week, it prompted smiles

The happiness, hiding, was already there

That one person saw, if just for a while

That kindness exists, that some people care

How we live, geographically wandering

Who we are, that migrates too

The key is to see any chances we're squandering

Why would you question, you being you?

The world's changing now, in, every, way

It is where you are, it is steering per se

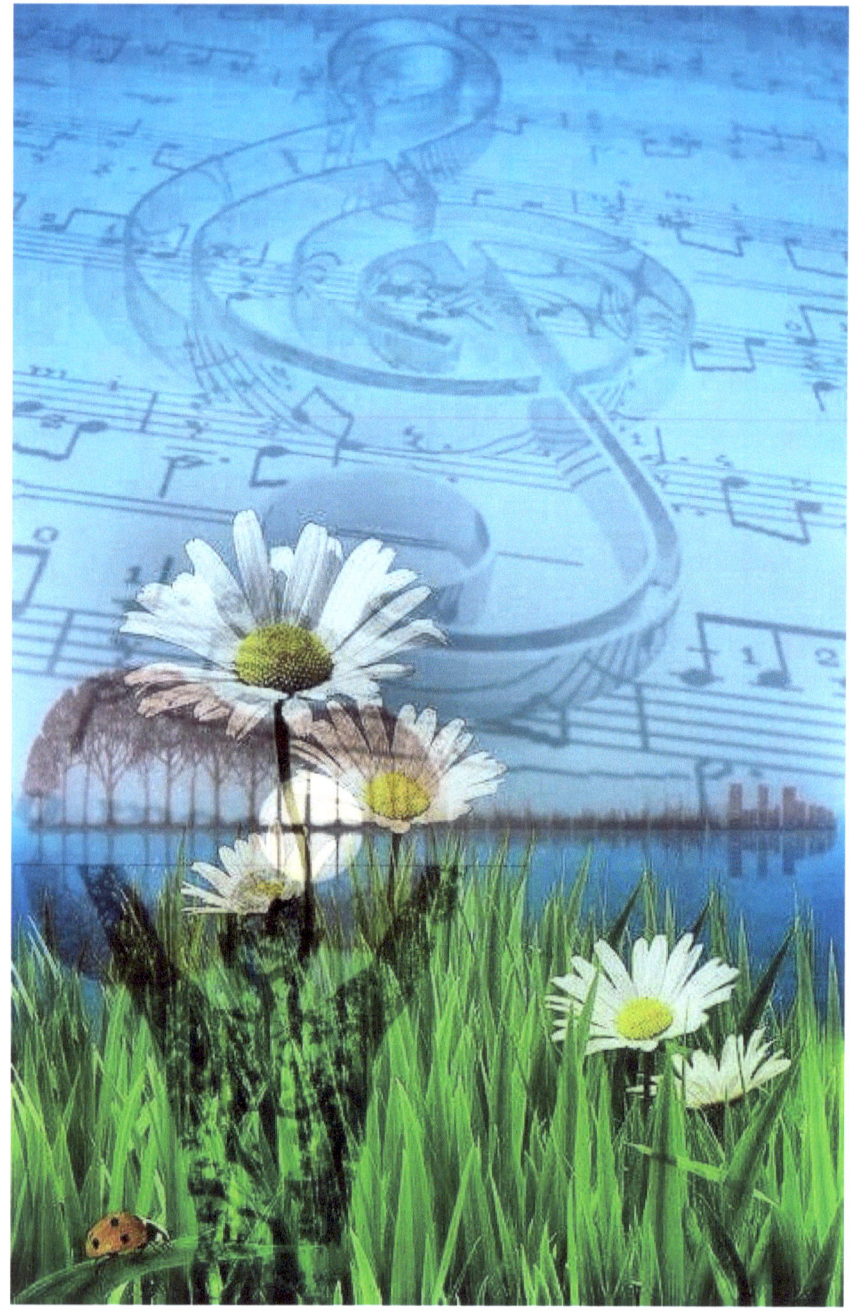

We all look up and see the sky

Baby blues coloring the days

At times the grays can see us cry

At night it lights in hopeful ways

We stand in colors, dependent on wind

Whispering its context in how it blows

Hearing its rhythms then and again

We need that sound, somehow it knows

Look at some daisies to offset your grays

Hear the guitar talk back to the wind

See your space in loving ways

Making music is almost never a sin

Some people can't see and some don't hear

And yet they walk in avoidance of fear

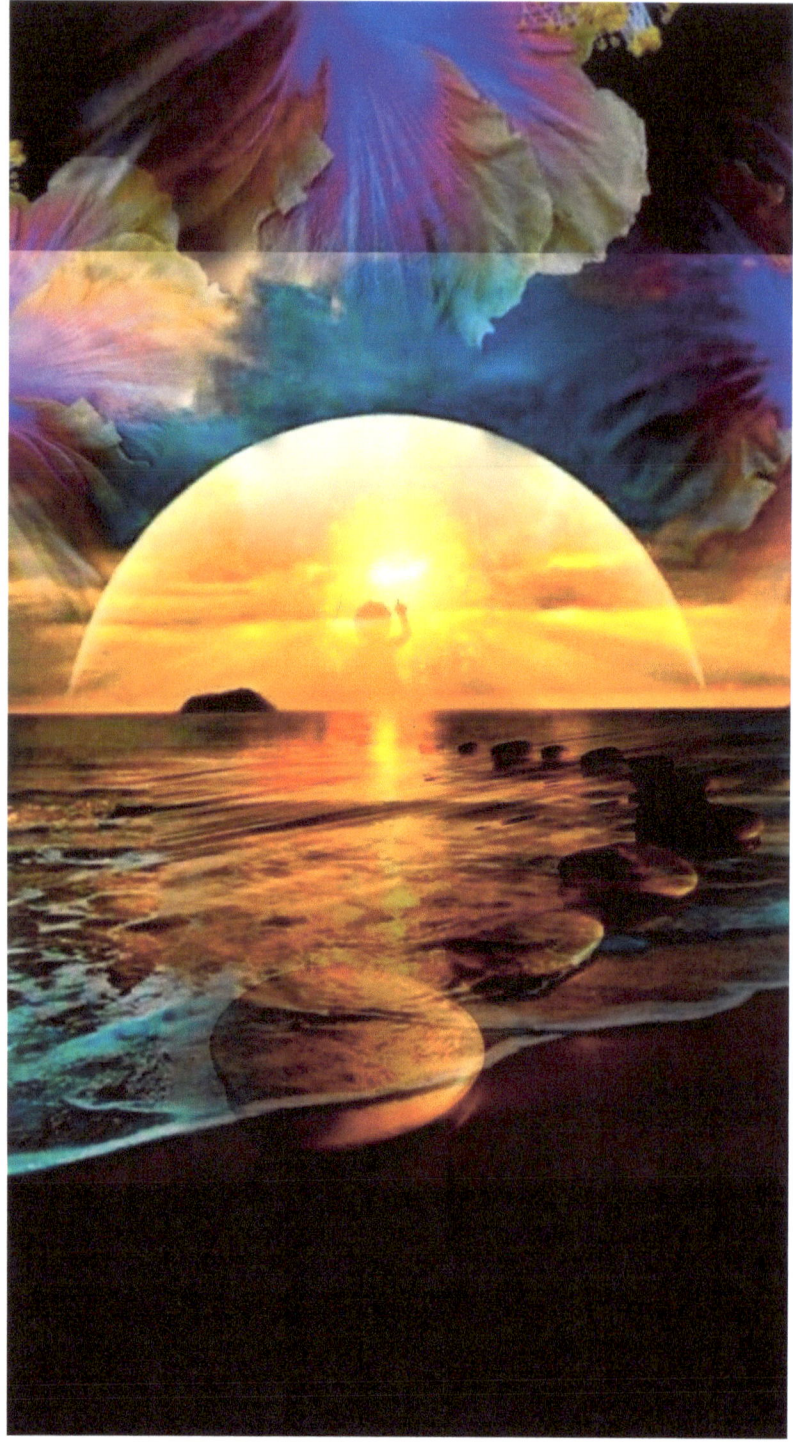

Pieces of life, all born in our eyes

Time together brought the deepest emotions

Beings that touched the tides of our lives

All of their memories flooding our oceans

The pieces were moments that built our heart

Colors of passion painting their lines

We knew they were special, right at the start

Ends of their lives, just transitional signs

Ends are beginnings if thought of that way

All of their golds not wanting to stay

Stuck in the sunsets that we saw today

Blown away by breezes that brings what they may

Best friends in our lives only stay for so long

Take comfort in knowing they're part of our song

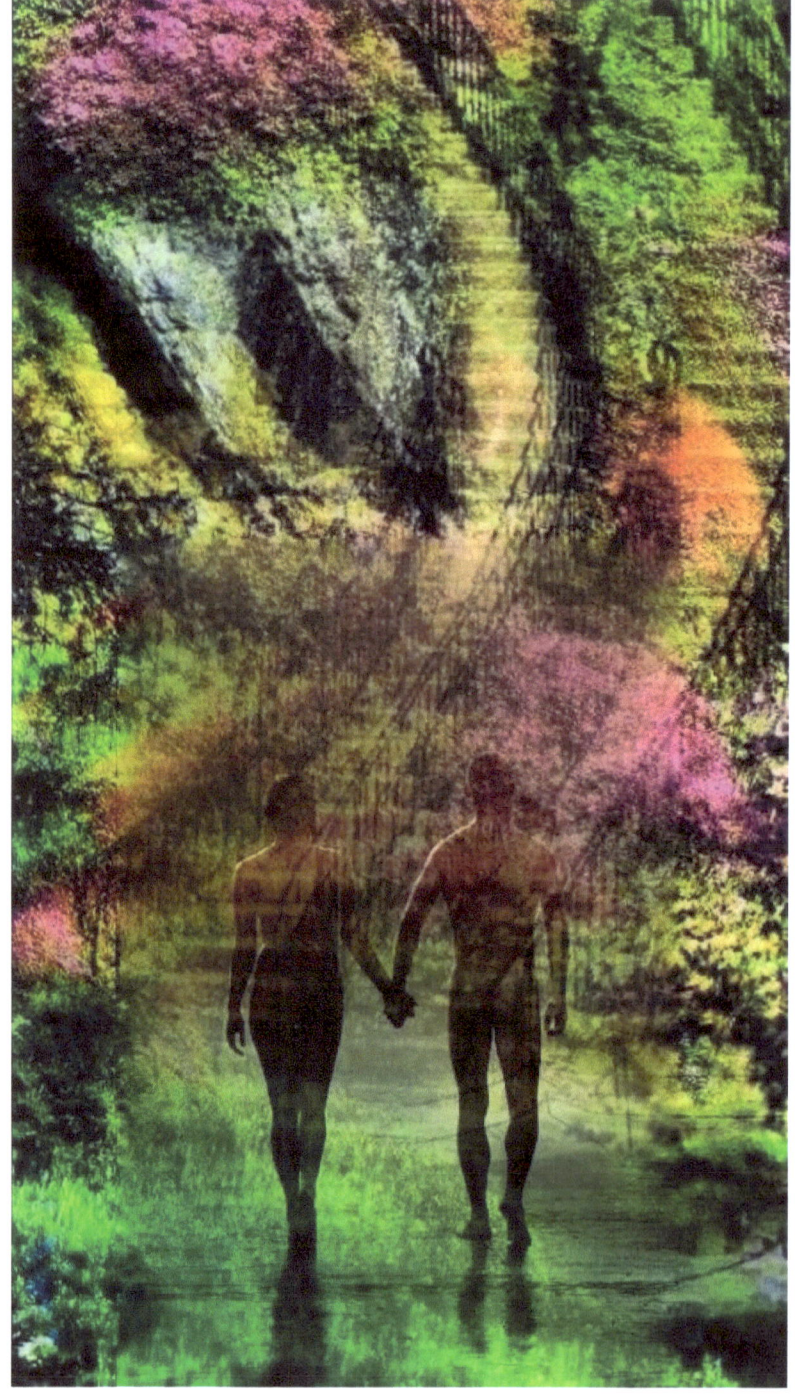

Never say never ever again

Never say always even before

Sometimes sometimes is when

Every thought after wishes for more

After we say what we already said

We wonder if it could have been better

But said what we did from language we read

Bodies and faces forming the letters

Words we write and things we say

Come to us in a moment's time

Many were not intended that way

But sometimes the best words come in rhymes

Never regret saying what you thought

You'll learn exactly what was meant to be taught

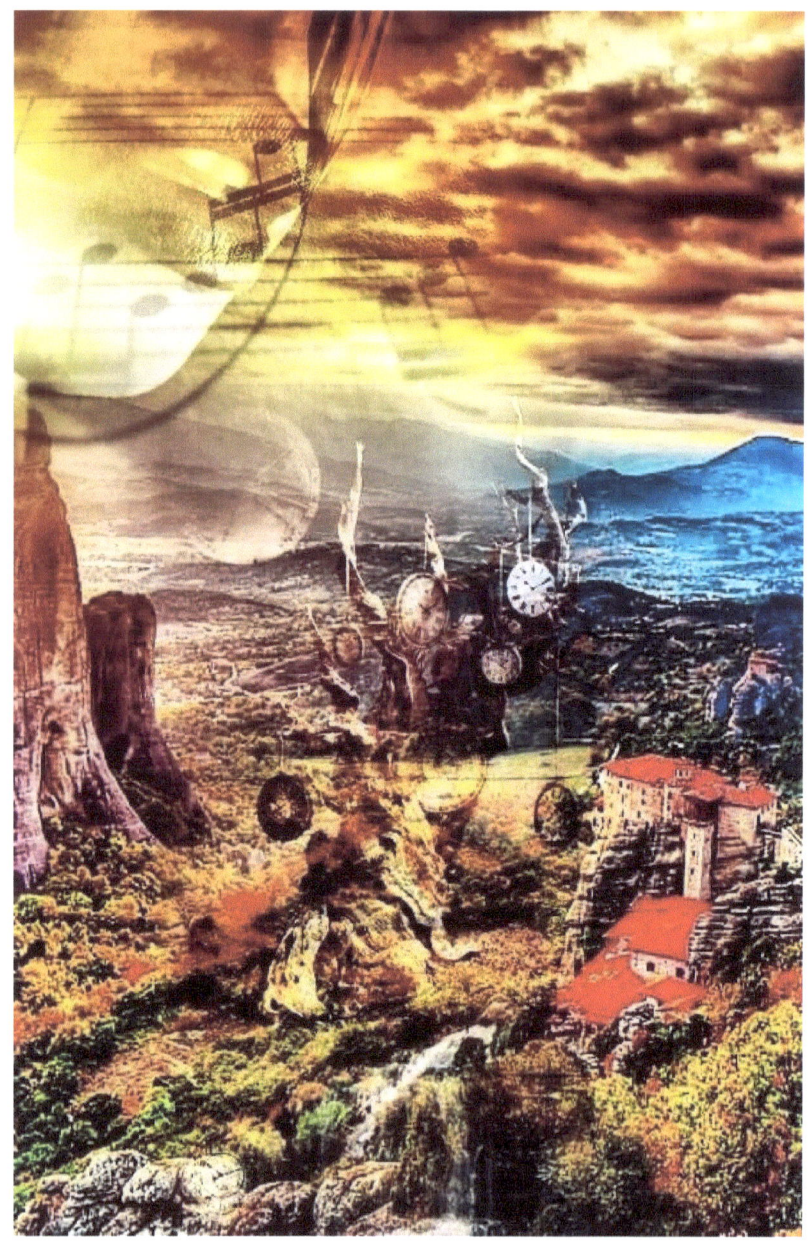

Owe your music and what is heard

Pay with gratitude's form of currency

Listen as you speak your words

Enjoy awareness granted through literacy

Eat your words, tasting their flavor

Pallets telling only tasteful truth

The best of words are words you'll savor

The innocence of flavoring youth

Older now, a meal you make

Sustenance leaning life so forward

Enjoy each savored bite you take

And see the end you're coming towards

Time is the meal we're forced to eat

The life after life, the greater treat

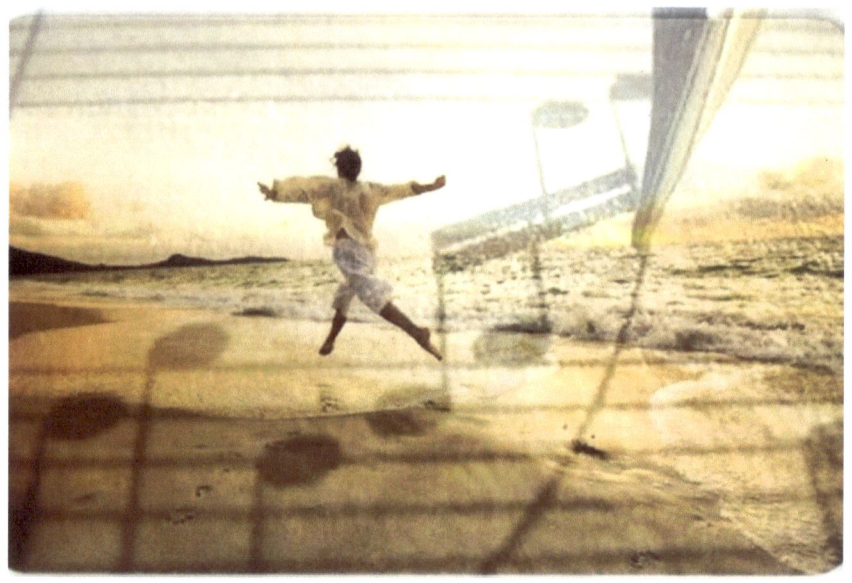

Your favorite song personified
But how do you choose just one?
You're older now, they've multiplied
And all of them are so much fun
For some, you must be in the mood
In others, that line you don't like
You realize some are being rude
And risk hard feelings through the mic
You know that songs are people too
Some in tune and others, not
So many say they're liking you
And some of those, you wish you forgot
The songs all come to mind for reasons
Through all your years, your life they seasoned

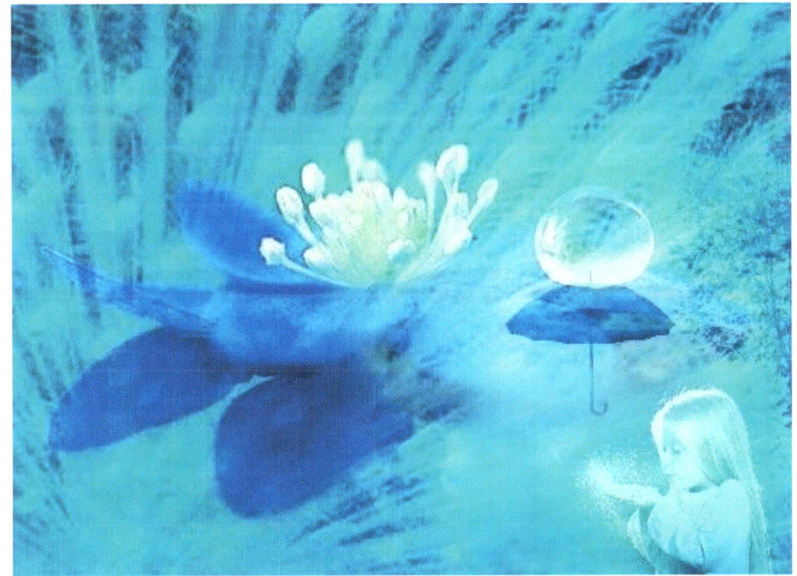

The inner child imagines
What the older one forgot
Age is bound by wisdom and fathoms
The risk that youth can knot
What are the perfect qualities
Of grace and fun compared?
Facing certain dualities
Convenience of memory spares
In order for us to feel free
Wisdom and grace are sometimes abandoned
But only briefly, so we can still see
Society's revelations in tandem
Let most fun happen when society's not here
Behave in public, in private, be freer

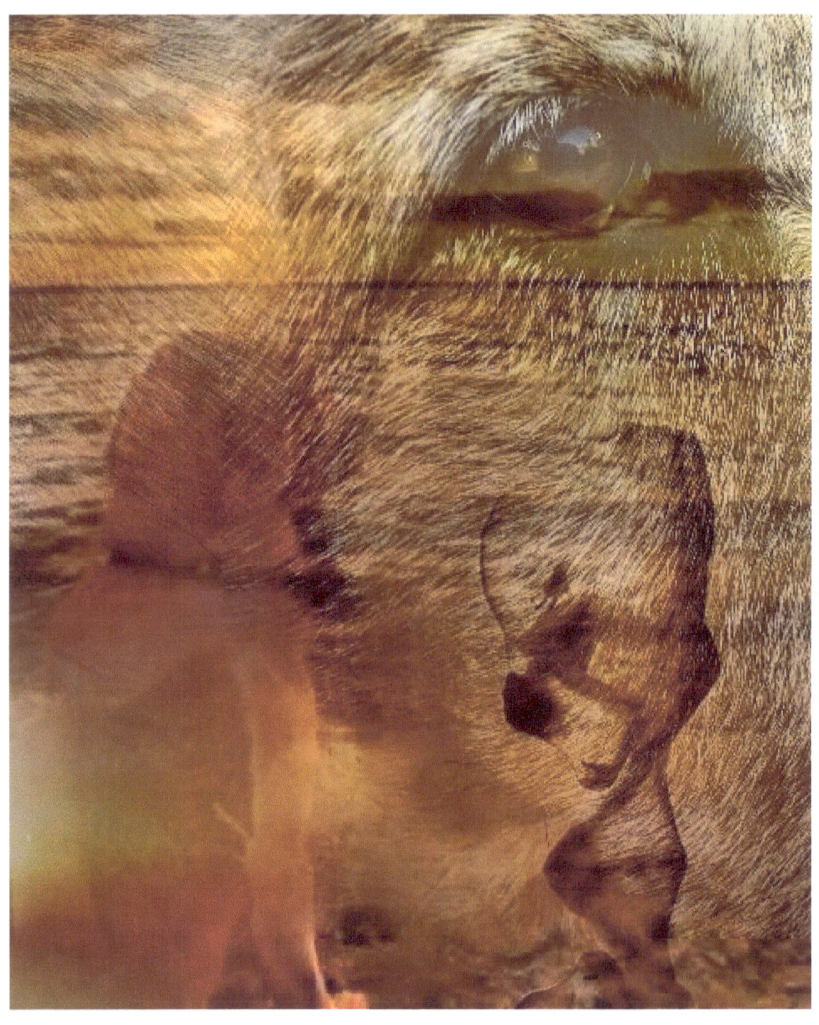

The eyes of a dog are the soul of the world

Taking on all of the pain humans feel

Sleeping in peace, in a circle, they curl

Awaiting emotions we refuse to reveal

They feel those sentiments need to come out

So they come and raise their mirrored eyes

When we don't get it, they look about

Waiting until we realize they're wise

When we get it we pet their head

Like we knew we were going to all along

Their work being done, they go back to bed

Always returning when something is wrong

The eyes of a dog absorb all our pain

We say thanks to them, by praising their name

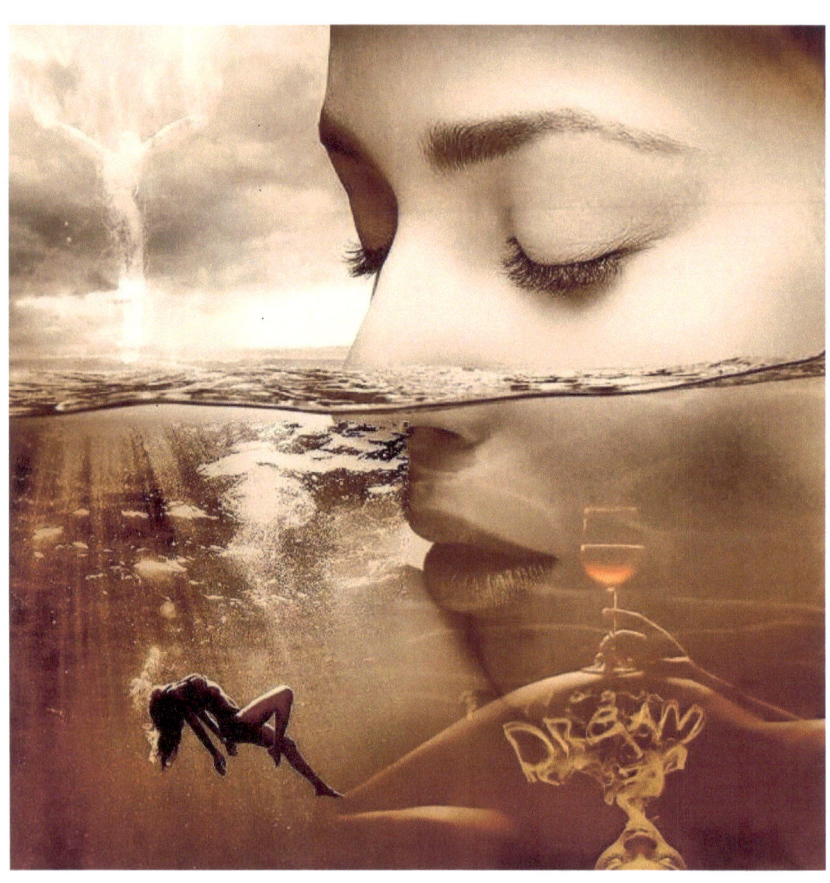

We watch the bubbles pass the top

Quickly ascending, right after the pour

Wishing the troubles, a means to stop

Life depending on water, more

Air and water proportion their feed

Both give us life, in each their own way

The haves presenting their own simple need

The wants, for better, or worse, they play

The year ahead is an open field

We plant more seeds of love and hope

The dreams we plant give different yields

Depending on the breadth of scope

We watch dreamy bubbles breach the surface

When we pour our glass with a sense of purpose

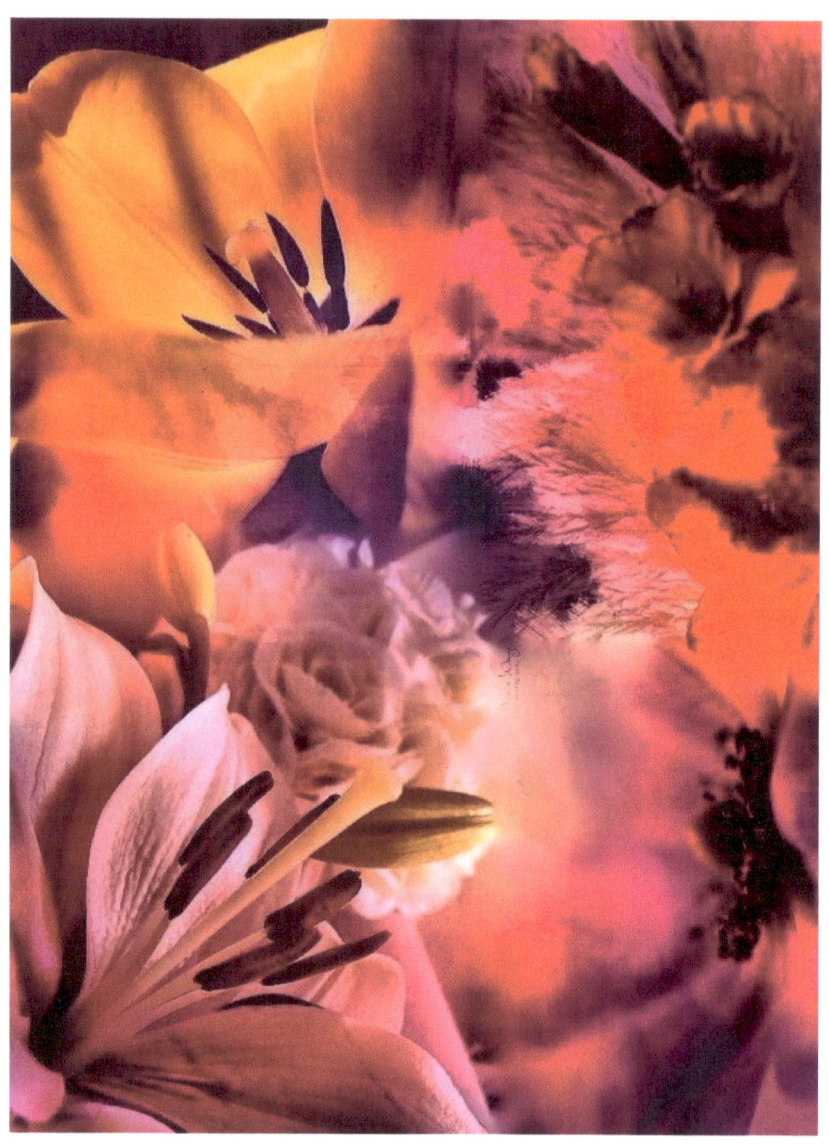

The voices of family and best of friends
Aren't always within our vision's reach
Like flowers though, they come again
Like waves, they always stroke the beach
Surround yourself with nature's voices
And know their symbols of comfort and color
See the angels make their choices
Equate the meanings, one being another
Your loved ones, angels that come in waves
Are always there, they're at the beach
Passionate hearts are ones that save
Giving hearts are the ones that teach
Lonely times, spend in contemplation
Values, when caring, breed appreciation

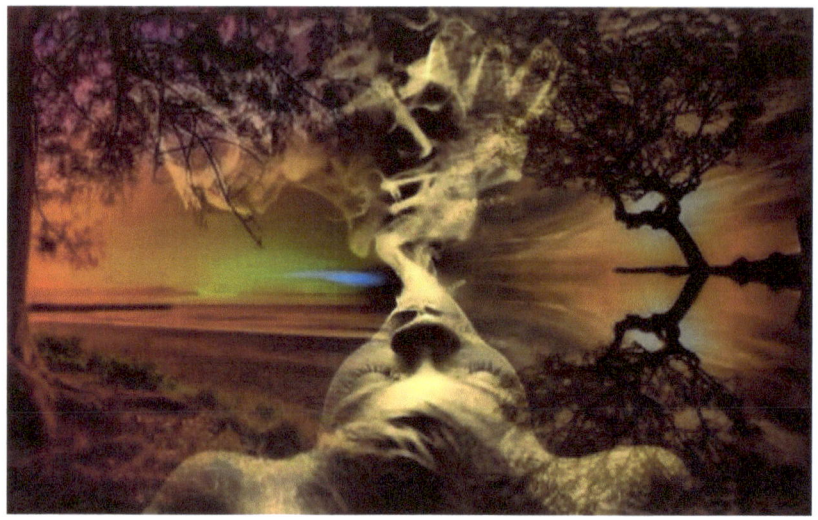

The music of moonlit nights
Is heard, if you wish to hear it
The sound of silence rarely lights
The dreams that come, and try to fit
A dream is a mystery, rarely solved
So much so that we forget
Strangers who become involved
People that we've never met
Tired eyes clouded last night's tunes
Like a party where something's wrong
Add the music sung by the moon
To correct the keys of last night's song
A night, not silent, carries a tone
The sound, a whine, you're not alone

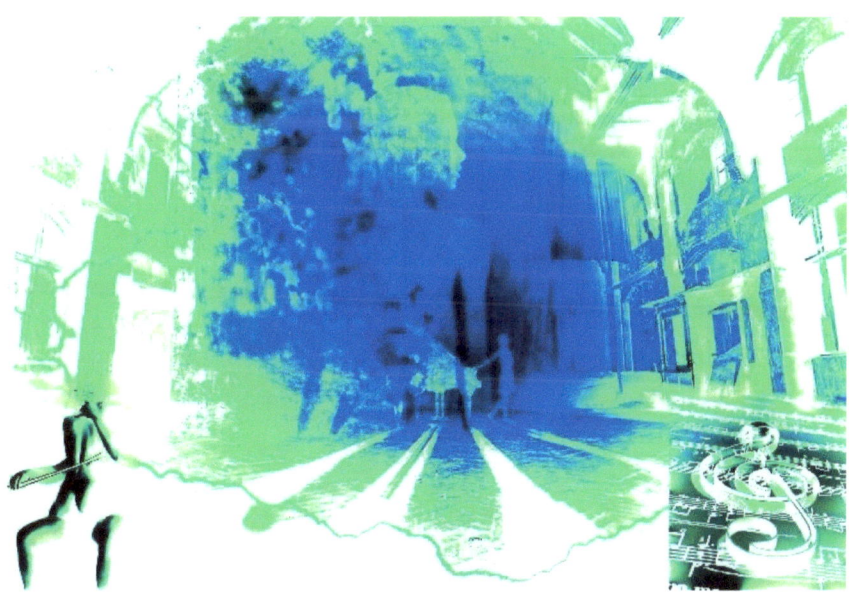

The end of the song is the hardest to write
Beginnings come from sweet moments in time
Opening lines, full of thrilling light
Hopes and dreams writing all of the lines
The tempo seems to set itself off
Having its own set of rhythmic minds
The keys of the chords sound better when soft
The chorus is what life's rhythm finds
The chorus changes, ever so slightly
As wisdom tries its hand at writing
Bringing security, bringing it lightly
Prepared to absorb brilliant strokes of lightning
The end of the song isn't something that's wanted
The chorus, the rhythms, we love what they flaunted

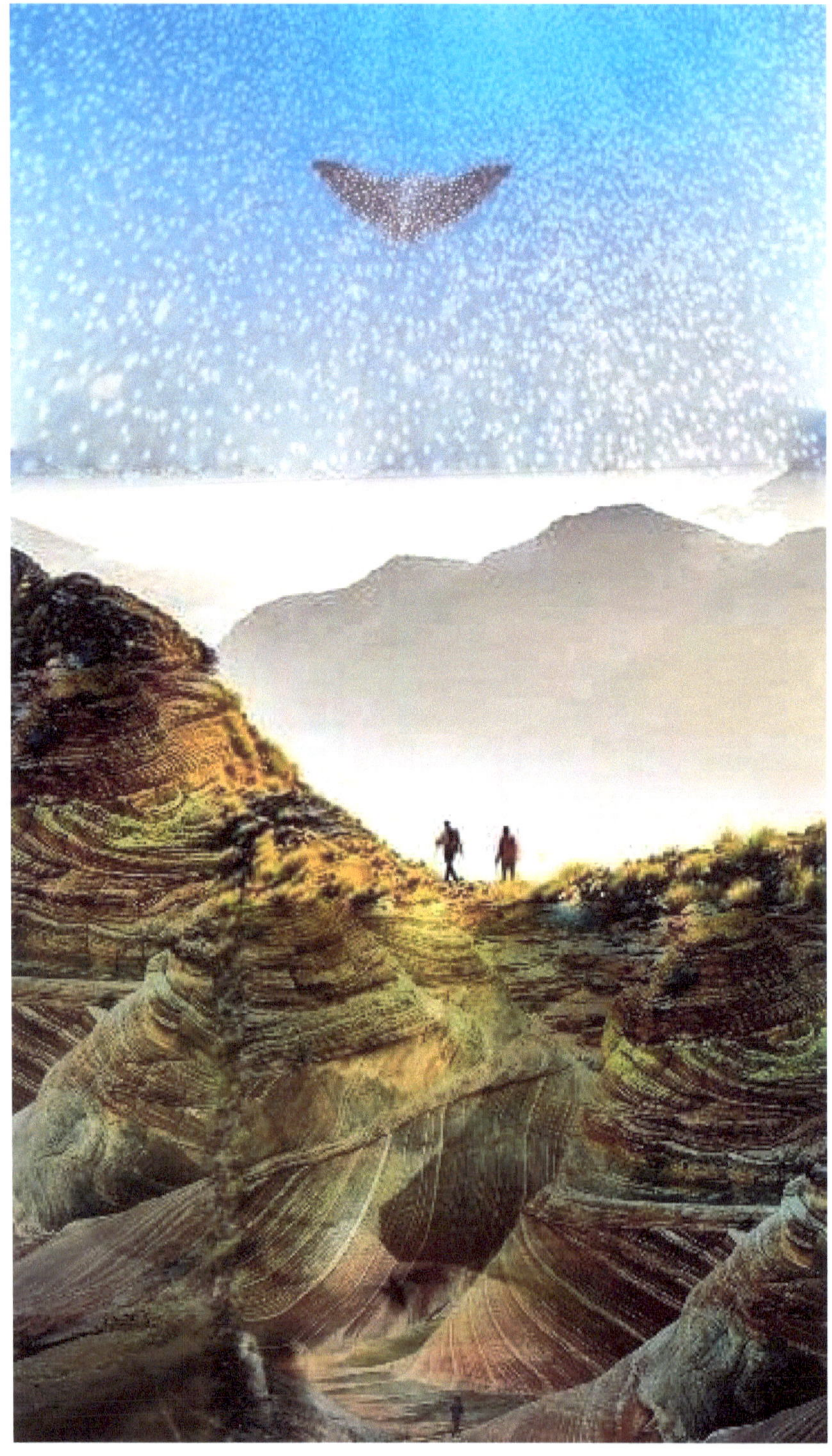

Were I to write one perfect verse

I'd need to use past, just to say it right

Sometimes life needs to be practiced first

Then planned the next day, and put in new light

When light is new, we start our day

Hoping to let our loved ones feel free

Never to force, with words that we say

Expectations, we don't wish to be

The now is created in every second

It's hard to accept the shards of time

Fired, all at the peace that we beckoned

Accepting it all, in all of one mind

Live your day while expecting to see

Imperfections in you and in me

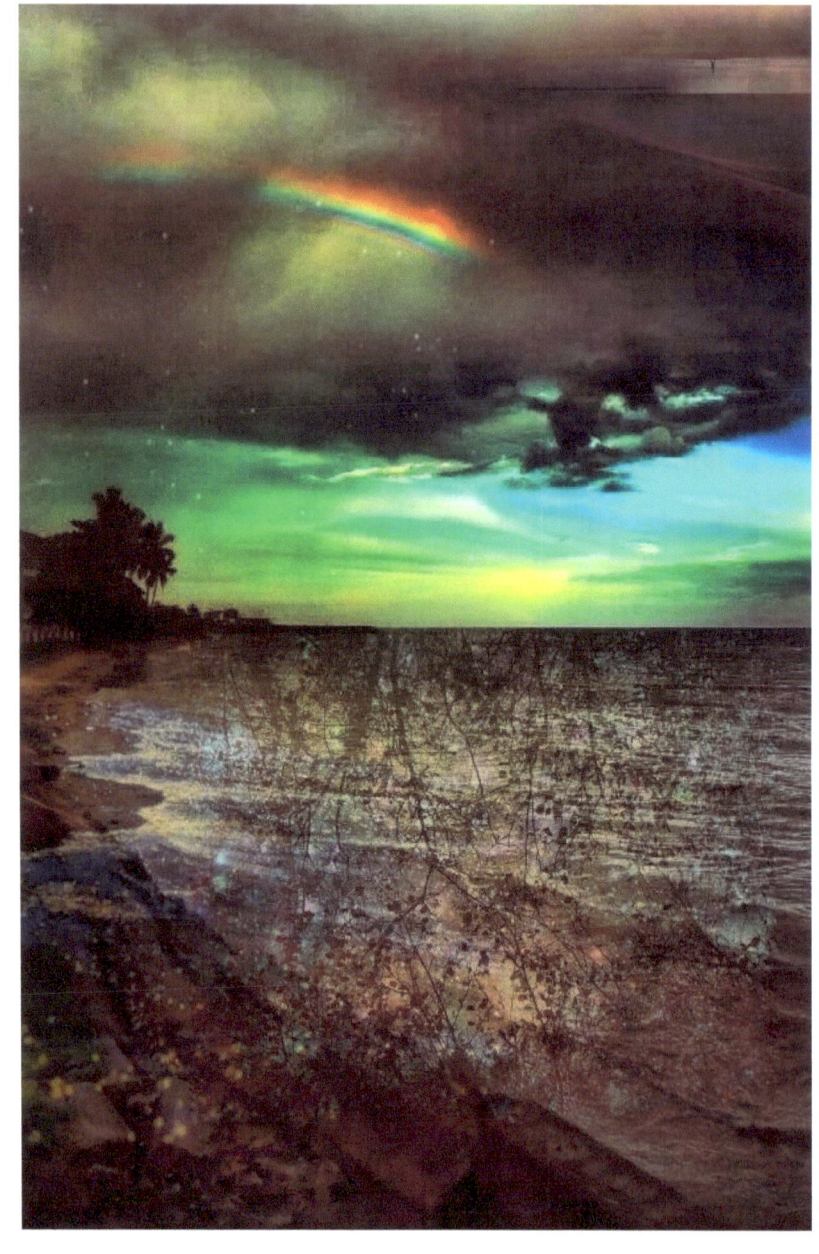

The morning can be beautiful
But mist upon its early arrival
Time passed chance at its disposal
And caught the details as usual
A chosen few have set the table
To please a slow path to the day
Eyes open now, or when they're able
To see the missed have gone away
Rainbows rarely come at dawn
Their promises yet to be made
The finite details going, gone
They're mostly hidden in the shade
The day, it dawns, with appreciation
At night, light's gone, its loss; persuasion

ABOUT THE AUTHOR

He altruistically arranged some words and blended some images in hopes that a reader who experienced it would benefit from the experience.

Even if that benefit, was simply the hint of a smile.

www.ingramcontent.com/pod-product-compliance
Lightning Source LLC
Chambersburg PA
CBHW041057180526
45172CB00001B/2